BARNS
of
WESTERN CANADA

KIRBY

BARNS
of
WESTERN CANADA

Bob Hainstock

FIFTH
HOUSE
PUBLISHERS

Front cover image: The Winn barn in the Bellbeck district of
Saskatchewan was one of several round barns built about 1910–12
by Joe Coe, an American immigrant. / Bob Hainstock
Line drawings by Jim Kirby, Winnipeg
Cover and interior design by John Luckhurst / GDL

The publisher gratefully acknowledges the support of The Canada
Council for the Arts and the Department of Canadian Heritage.

THE CANADA COUNCIL | LE CONSEIL DES ARTS
FOR THE ARTS | DU CANADA
SINCE 1957 | DEPUIS 1957

We acknowledge the financial support of the Government of
Canada through the Book Publishing Industry Development
Program for our publishing activities.

Printed in Canada.

98 99 00 01 02 / 5 4 3 2 1

CANADIAN CATALOGUING IN PUBLICATION DATA

Hainstock, Bob, 1945–
 Barns of Western Canada

ISBN 1-894004-18-3

 1. Barns—Canada, Western—History. 2. Barns—Canada,
Western—Pictorial works. I. Title.
NA8230.H34 1998 728'.922'09712 C98-910691-8

Fifth House Ltd.
#9 - 6125 11 St. SE
Calgary, AB, Canada
T2H 2L6
1-800-360-8826

Contents

∾

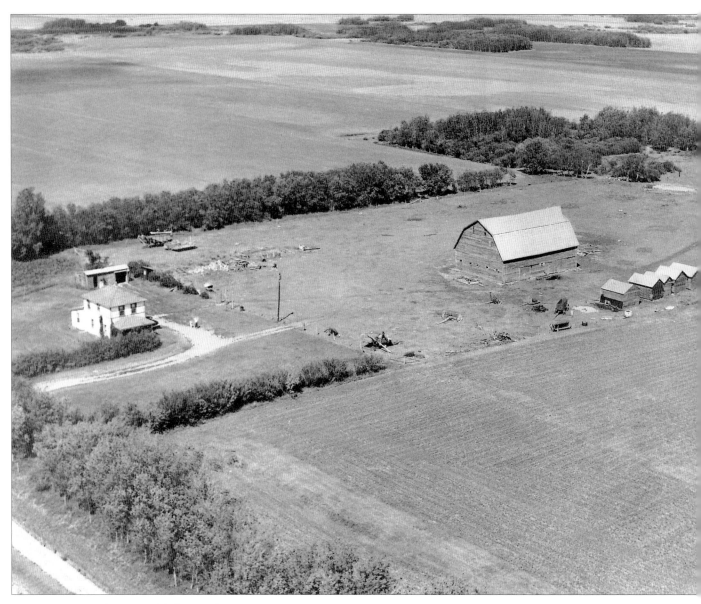

1. An aerial photographer circles the Hainstock farmyard as it existed in 1949 near Baldur, Manitoba, including the large barn that was the centre of life for four-year-old Bob and twin brother Clayton.

Author's Foreword

Unlike eastern regions of North America, Western Canada cannot boast several centuries of barn building. Nor does it have the indigenous forms of agricultural architecture, as does Europe, which can be traced to earliest recorded times. Western Canada has only a century of barn building to celebrate.

Why then is our inventory of historic barns so rich in comparison to that of other nations? And why is such a significant link to our heritage threatened by neglect and abandonment?

The answer to these questions lies in our brief but dramatic transformation from a gigantic "buffalo run" to the greatest granary in the world. Never has the world experienced anything like the migration of settlers to Western Canada around the turn of the century. It was tied directly to another phenomenon, an unprecedented mechanization of farm operations that pushed millions of surplus country folk into cities and factories, which in turn created cheap labour and the future means of farm mechanization.

The effects of this massive social upheaval are still with us today—at least in our surviving barn designs. Indeed, to the student of farm architecture, barns tell the story of the settlement of Western Canada more dramatically—yea, poetically—than a ton of textbooks.

This period between the mid-nineteenth and mid-twentieth centuries was a golden age of barn building. The newcomers brought remnants of building traditions from other lands. To

> *In the foreseeable future we will be left with pictorial or wordy tributes to these threatened landmarks. Will we accept this as inevitable, or will enough people care sufficiently to ask that heritage legislation include our barns?*
>
> CAROLYN O. NEAL, *ARCHITECTURAL CONSERVANCY OF ONTARIO*

these were added adaptations made through the influence of New World materials and the experience gained from farming in eastern North America. Finally, the epoch closed with the introduction of bright, shiny new efficiencies that would change the face of modern agriculture, doing away with the horsepower in the original sense and eventually rendering the horse obsolete.

Now is the time to increase public awareness of this great cultural legacy in the hopes that some of the more symbolic examples that dot our agricultural landscape are rescued before they vanish. Perhaps this book is a small beginning.

There is, of course, a very personal side to the endeavour.

Things seem to have started that hot, humid afternoon in the summer of 1982 when we pulled to the side of a narrow country road near Baldur, Manitoba. We were looking for the farmyard where my twin brother and I had been raised nearly four decades earlier. I hadn't been back in nearly thirty years and the visit was special. With me were my eight-year-old son, Ryan, and six-year-old daughter, Meagan—both born in the city and on that weekend getting a tour of where their great-great-grandfather had settled in the 1880s, and the region where subsequent Hainstocks had farmed until the 1950s.

Rattling along in our old half-ton truck, the kids were getting the well-worn stories about when Dad was a boy on the farm. The pet pigs and a favourite story about our one-legged pet

chicken. Talk of large threshing gangs and fall hunting parties. Tales of bewildered baby rabbits found under drying stooks, or the adventures near frog-laden sloughs. The castle-like barn filled with stray cats and hungry kittens. The same barn and its cavernous hayloft, perfect for a pair of would-be paratroopers and their reluctant wonder dog, Sandy. That barn, again, with deep, dark stalls that housed the huge, powerful draught horses or doe-eyed milk cows. A barn sometimes filled with fragrances both sweet and harsh—at times bursting with the thunderous noise of man, animal, and birds, at other times almost collapsing under a perfect silence.

Such memories were those of a youngster barely into the elementary grades of the one-room schoolhouse down the road. I was fully expecting them to be scaled down to reality when I arrived at the nostalgic site. But nothing could have prepared me for the green emptiness where our farmyard was supposed to have been. No house. No barn. No trees. Nothing but a ripening crop rolling under the gentle persuasion of the winds.

That afternoon tour continued with trips to other childhood haunts I wanted my children to know about. Later at home, as I pulled out some old family photographs, attentions were fixed on the barn. Together with photos of vintage farm buildings around the province taken during my years as a reporter, the barn print seemed to trigger a curiosity that has been difficult to explain or satisfy.

It still took encouragement from fellow farm writer Janet Hunter to persuade me to ask our editor to consider a series of old farm buildings, mainly barns, on the cover of the *Manitoba Co-operator*. The series lasted two years and drew the biggest single response to any feature in the weekly newspaper's history—five hundred to six hundred letters from across Canada and even from points in the United States.

Whether travelling the dry, choking backroads of central Alberta, or the narrow switchbacks of the western mountain ranges, the elation of discovering an unusual barn design or an interesting family story has remained the same. Every single barn had at least one feature to distinguish it from others in the area. Some might pooh-pooh this as the kind of romantic claptrap one would expect from a writer too often anchored to a city desk. But after logging almost 30,000 miles into every corner of each western province; after seeing and exploring thousands and thousands of barns; after extracting a small mountain of information and photos from archives across Canada and Europe, I feel this thesis is well and truly proven. The diversity of barns featured in this book speaks for itself.

For each and every barn pictured, and for every one of many hundreds that did not quite make it through my editing process, there are at least another dozen that deserve to have been included. I might have been looking the wrong way as we crested a hill. We may have taken a wrong turn off the highway. Or, it might have been too late in the day to stop and check out a far-off silhouette that normally would have been worth investigating. One thing we did learn was that not even neighbours necessarily appreciate what they have in the district. How many times did we stop to pass the time of day with a local resident, asking if there were any particularly interesting old barns thereabouts, and receive a thoughtful but firm, "Nope." A few minutes later we would be off down the road, only to come upon a rare beauty of a barn. It is easy to take for granted what one sees every day.

We have tried to make this book a visual example of the best in Western Canada, whether in black and white, representing what has disappeared over the past few decades, or colour, representing those barns that can still be seen on lonely horizons. We wanted to produce neither a "pretty picture book" without historical value, nor a dry, ponderous recitation of dusty data only an academic could love. Too often, as has been said, the latter's prose "skips the bucolic and heroic stages of architecture's small hours, and presents instead a bewildering catalogue of monumental minutia, generously asterisked and dragging the ball and chain of footnotes."

If one were to admit any shortcomings in this book, this would be a fine place to do so. First, the book should have been written forty or fifty years earlier. Of more than 500,000 barns that no doubt existed at an earlier time, it is questionable whether one-third have survived. Of these, only about one-third might serve any useful purpose other than casual storage.

Second, it is impossible to capture all the moods or elements of the Western Canadian barn in a project such as this. To see a majority of our farm buildings would take many decades of searching. To record the beauty and drama of elements surrounding the barns would take many lifetimes.

Third, the majority of barns contained herein were shot in their "natural" environment, the farm. But many are also located in parks and villages dedicated to heritage conservation. While some purists might question their inclusion, we promote them quite strongly. They are often the best maintained, the most accessible, and sometimes the last of a kind. Almost all are originals, while a handful are authentic re-creations. There should be hundreds more such pioneer and heritage villages. If each municipality preserved one or two farm buildings, the future of our past would be assured.

I have used the term "we" quite often. Although I claim to be writer, researcher, and photographer, the book is a family project. My wife, Judy, did much of the archival work in Manitoba and Saskatchewan, while my sister Jerri handled similar chores in Alberta and British Columbia. Each took considerable time away from her own profession to assist. My brother Clair handled translations and some Eastern Canadian assignments, while brother Clay helped unearth some excellent sites in southern Saskatchewan. Moreover, on the occasions when the project started to fall apart, the families were there to encourage another try. This one's for them: Jim and Sally, Clair, Clay and Linda, Jerri and George, Clair and Ella, Don and Lenore, Chuck and Annie, and Doug, a special someone who set the highest standards for the rest of us a long time ago.

Two people who deserve very special thanks are my son, Ryan, and daughter, Meagan, who more than fifteen years ago suffered through thousands of miles of barn searching and thousands of photo sessions. Today they are working on their second and third university degrees, but are also equal partners with me in researching, writing, and photographing a new book on the barns of Atlantic Canada, due out in 1999. That alone makes the western barn project worthwhile.

There is another side to this business of producing a barn book. It is called sponsorship, without which there would be very few such books available to the general public — at least not at affordable prices. A warm expression of thanks is due to the Canada Council who supported my early research and travels, and to Manitoba Pool Elevators, a special kind of employer and co-operative who showed confidence in the project, and thus an appreciation of western heritage. How valuable this support has been cannot be stressed too strongly.

There are others who round out my special list—people who gave unusual assistance when asked, or advice and encouragement without being asked. Or perhaps some could have flattened the enthusiasm of a struggling amateur author-photographer, and thereby ended the project. They didn't, so here's to:

Ed Ledohowski, Murray Cormack, Bob McGuinnes, Thora Cooke, Bill Morriss, Sig Bradshaw, Ron Britton, Dr. Karl Baumgarten, Arne Berg, Anne O'Dowd, Franz Gebhard, Sirkku Dolle, Olav Hjulstad, Karen Liddiard, Greg Arason, James Pask, Joyce Chergin, Louis Molin, Hazel Britton, John Lehr, Ronald Woodall, Frank Korvemaker, Norma Johnson, Alice Pocock, William Miller, Alice Laing, Stan Eichhorn, Harris Workman, Niel Heuser, Keith Dryden, Jeremy Robson, and Donny White.

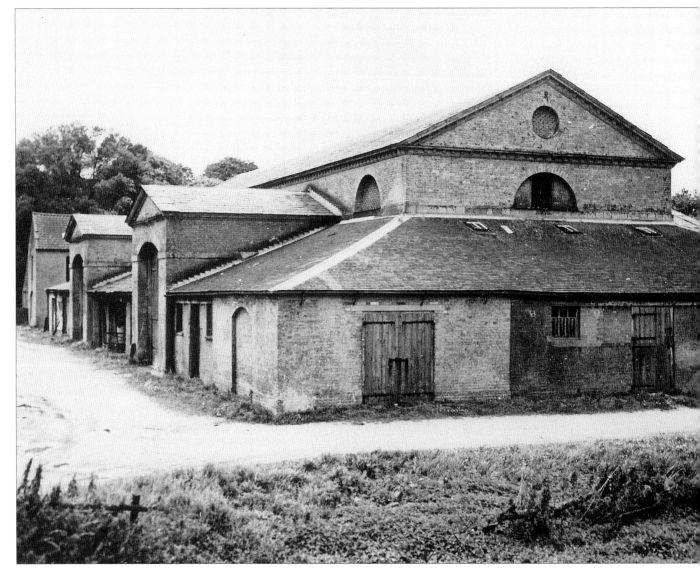

2. Brick tithe barn near Norfolk, England, notable for its many entrances to the main storage area, as well as smaller stable doors on the perimeter.

Introduction

We are all not talking about preserving the old barns to benefit an elitist minority. The old barns are of the people, the common people who live on the land, and their preservation is for the people, all of the people. Everyone has roots that trace back to the land. And the old barns are of the land.

JERRY APPS, *BARNS OF WISCONSIN*

Whenever hunters exchanged ancient nomadic ways for the permanency of settlement, the barn in its many forms provided the means to store food and domesticate animals for field work. Yet, scholarly attention to barns has been almost non-existent. The world's collection of known works might take up only part of a short shelf in a minor library.

It is only in the past two or three decades that barns have been studied in any depth, particularly in the more temperate countries of Europe. This is of special benefit to fanciers of Western Canadian barns, as these countries provided the majority of immigrants and a background of traditional building methods during the last century.

Most researchers agree the word "barn" is of English origin from the words "bere" (barley) and "ern" (place), although its printed use was not noted until the 1600s. However, "barn" has been used to describe different types of buildings in different countries. Prior to North American development of big, multi-use barns, cows were generally quartered in a byre, while granaries were used exclusively for grain storage and a small stable housed the horses. In poor areas of Europe some or all of these functions were combined under one roof.

According to work completed for a United Nations study of rural architecture in Europe, farm building designs tended to be more individualistic in northern regions, but were clustered around what might have been castles or manors. It is suggested that early farm architecture in England, Spain, and other areas of southern Europe tended towards more crude construction styles, as emphasized in temporary shelters and longhouse styles that were simply extended as stable and grain storage needs dictated.

In this longhouse category, the study indicates three related groups of design: first, Germanic areas, plus Belgium, Luxembourg, and northern France; second, the stretched longhouses of Ireland, the Paris area of France, and Celtic regions of England; and third, a longhouse theme combined with the Mediterranean style of tiled, low-pitched roofs in eastern Germany, central and south Austria, and Switzerland.

Without national exception, there has existed a wide gulf between the farm buildings of peasant and landowner. At the lower end of the eco-

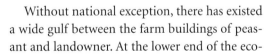

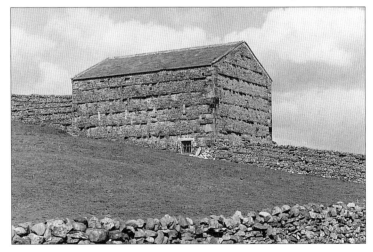

3. Yorkshire, England.

nomic ladder, life's goals continued to be family self-sufficiency. At the other end, large, well-maintained barns housed the collective output of large estates. When a new type of landowner began to appear in several old countries almost two centuries ago, it was to fill a middle ground between the two economic extremes. It was this new class of farmer who first saw the potential of far-away North American farmlands. It was they who proved the New World's agricultural promise.

The United Kingdom provides some of the most relevant background for an informal study of early barns and granaries. Traced back to the fourth century, the British barn had a unique shape, but a simple beginning. The shape was created by each of two sets of trees tied at the top to form gable ends. These "crucks" formed a curved roof not unlike the hull of a large, up-

turned ship joined by a large ridgepole, with curved walls completed with a weaving of wattle sticks and plaster daub.

Some of the oldest barns in Britain are the enormous tithe barns, about one hundred of which are still standing. Some date back to the thirteenth century, including many owned by feudal lords and built to house commodity taxes imposed on those who farmed their lands. Most tithe barns were the central storage depots for the huge agricultural estates of tithe-collecting churchmen. One of the largest and oldest surviving examples is the Great Coxwell of Berkshire. It measures 152 feet by 44 feet, which by Western Canadian standards would rank only a little above average.

As such, tithe barns tell us little about "average" medieval farm buildings. Indeed, some historians suggest the true descendant of the tithe

wasn't the farmer's granary or barn, but rather the town merchant's warehouse.

Popular history tells us most farmers were either well-to-do landowners or poor peasant tenants who frequently shared their shelters with farm animals. Britain was only one of many countries that featured the combination house-barn-granary. From medieval times until recent decades, regions of what today are known as Ireland, Scotland, France, Germany, Scandinavia, Italy, and Wales offer examples of one roof sheltering man, beast, and produce.

Such structures usually took one of two forms. One was a single-storey rectangular layout with stalls and stables flanking a long, central aisle, and family quarters at the rear of the barn. The other was a two-storey bank house-barn with the lower level reserved exclusively for farm animals and feed. The former style is frequently referred to as the "basilica" plan, and in Britain most often included the longhouses of peasant farmers. Such a layout was also central to the design of tithe barns of Britain and the large manorial estates of Europe, although in these latter cases man obviously did not share the earthy accommodation of animals and field produce.

Just as farm buildings are today, the barns of the Old World were nothing more than an extension of the social and economic patterns of the times. The size of barn was usually determined by several factors, but in turn the barn dictated equally important developments in both rural and urban life. For example, the stored hay crop had for centuries provided the main winter feed for British animals. The quality and quantity of barn storage dictated the number of cattle or horses that could be kept, and for that matter, the size of family required at home. Both factors determined the power available for field work. This directly determined the volume of surplus food available to townsfolk.

The initial role of farm buildings became clear as industrialized Britain moved from a combined population in Wales and England of 5.5 million people in 1700, to an estimated 26

million in 1881. The agricultural revolution in the same period was a guaranteed success because it was an absolute necessity. New fodder crops allowed more livestock, while pigs became domesticated from woodland scavengers. More animal housing was required, and at the same time manure as fertilizer became an obsession with farm leaders.

Labour may have been cheap, but barns became "muck factories." An example of how this era influenced the design and shape of barns can be seen in the recommended replacement of thatch or straw as a roofing material. As writers of the period noted, thatch had been a bad fire hazard for centuries, yet demand for the material never wavered. However, when thatch was needed as material for the midden, or fertilizer concoction of manure, thatch roofs all but disappeared.

One of the newer types of barns then beginning to make a substantial appearance on Britain's landscape was a modest three-bay brick or stone barn that would become known in North America as the English barn, or Yankee barn. Government propagandists urged its construction through the late 1700s, offering plans to grain farmers who required a threshing floor flanked by two storage areas.

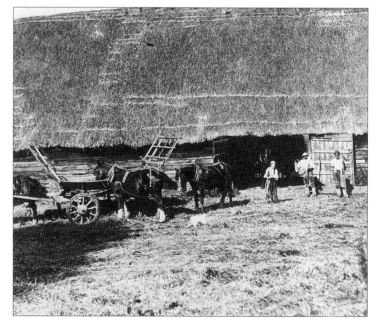

5. A large thatched barn at the turn of the century maintained by the Hampshire County Museum Service.

The design of incorporating wide doors on sides generally 25 or 30 feet in length, with gabled end walls usually half that length is also said to have been basic to most agricultural societies in Europe.

Government experts and farm publishers in the region continually pleaded for improvements to the shape and use of barns. Much of this advice fell on the ears of individuals who would soon leave for the seemingly endless frontiers of Canada or the United States. They brought ideas for traditional building styles with them, but also newer concerns for modern convenience and efficiency. The following excerpt from a periodical of the time illustrates the pleadings of British agriculturists as late as the early 1900s:

> We sometimes forget the large part of the life of the farm worker and farmer that is spent "somewhere round the yards." Much of this work is done in places which are dark, damp and drafty ... Poor as some of our urban factories may be, one would have to go down to the sweatshops of the East End of London to find anything as inefficient and uncomfortable as old-fashioned farm buildings. Farming with bad buildings is such a squalid job, that until this question is tackled, agriculture is bound to be a backward industry. But we dare not build because the industry will not stand it, and the industry gets worse because of the badness of the buildings.

The British farmer was caught between the manure pile and a hard place. Internal combustion engines eventually did to barn design what editors could not. Bagged fertilizers gradually reduced the need for the dunghill and allowed farmyards to be laid out in effective yet sanitary proportions. By 1960, a national survey of British farm buildings found that an average farm contained 2.5 buildings built since 1945, another 2.4 buildings built between 1918 and 1944, and 6.0 buildings that dated pre-1914. It was easy to start fresh in Western Canada because everything was new.

The farm buildings of Ireland also mirrored economic and social conditions. Probably the earliest recorded reference was a survey of the Manor of Cloncurry in North Kildare in 1305 that showed two small barns, a grain kiln, and a threshing house for corn, as well as a cow byre and pigeon house. Little changed in Irish farms in the next three hundred years, a fact commented on by visiting writers who also found mature Irish cattle badly underweight. They blamed this on the practice of reduced feeding and inadequate shelter during winter winds and rains.

Some farm buildings constructed during this period have become the oldest existing barn structures in Ireland. As with most other countries, surviving structures too often reflect privileged class materials and styles. The majority of farmers were men of lesser means and did not enjoy such specialized buildings. A survey of County Kildare in 1808 frequently found long, low, thatched farm houses, the front doors of which looked out on the barn and stable on one side, and the cow and bullock houses on the other side. Often in the front door of the dwelling was a manure heap, which, according to reports of the era, "was the object of wonder and disgust to many visitors in those times."

Great energy was later expended in the 1800s towards improving Irish farm buildings. However, because of abundant manpower in those days, little investment was made in labour-saving equipment or design. According to local researchers, these newer barns had few windows and narrow doors, and only the very best could boast a cobbled floor.

Moving to Denmark, one finds numerous varieties of barn styles, many of which have been preserved in public museums. A typical farmyard showed two large parallel buildings, one a family dwelling, and the other a barn. A shed or forge completed the farmyard, in which one also would have found a large dunghill and well. Barns built in the 1700s held separate compart-

6. The oldest farms in Ireland are often of stone. The roped thatch roofs cover the cowshed in the foreground and the house behind.

7. A Belgian barn with thick timber and nogging, the brick filling is a popular technique through Europe.

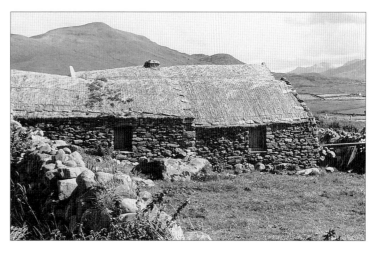

8. Another German living museum, showing half timbering or brick and nogging method of building.

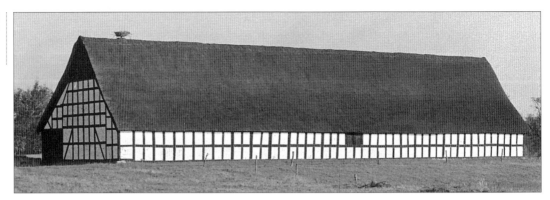

9. Wagons travelled the entire length of this timber and brick Jutland barn.

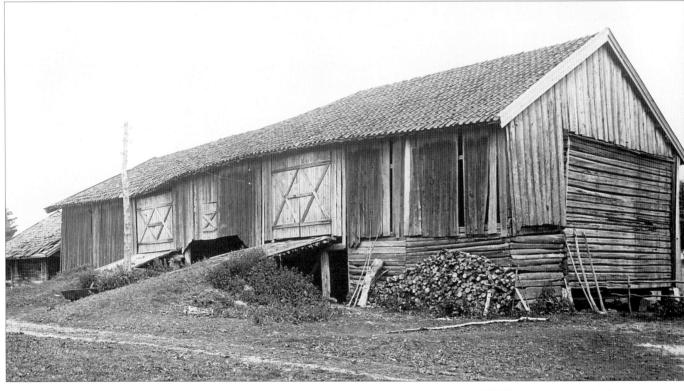

10. Vertical siding provides covering for this double-ramped granary and feed barn in Norway.

11. An example of a Norwegian barn with a threshing floor at the top of a ramp but only one fodder room.

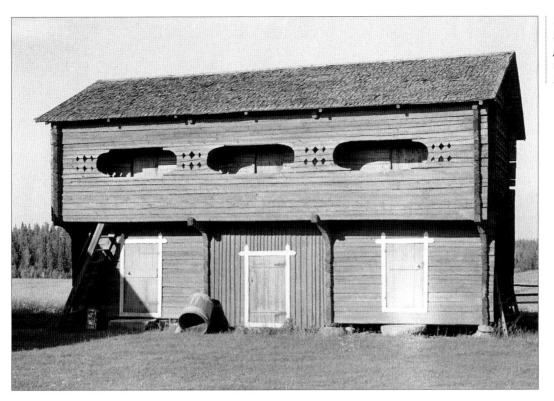

ments for grain storage, carriage storage, and repair, as well as a central threshing floor and fodder floor. Stalls for cows, sheep, and field oxen were found at one end of this multi-use barn. Most buildings of the time were thatched.

Heavily tarred timbers were another common feature of barn construction in parts of Europe. In Eastern Jutland, for example, a barn from an old manor estate displays well-preserved half-timbering, filled with either large bricks or friar stones. Sometimes called "nogging," the building technique was popular throughout Europe. This particular style in Eastern Jutland dated from the 1600s, and featured a long lean-to shed along one side with doors in each end. This allowed harvest wagons to travel the entire length of the barn.

In Norway, there were two main types of barns. The most common was similar to the English three-bay barn with a threshing floor in the middle, flanked by storage rooms for corn, hay, or fodder on either side. The other common style featured a simple, one-room log structure for fodder only.

Whereas masonry materials such as brick and stone were frequently used for larger British barns until the end of the eighteenth century, wood or a combination of wood and daub (a plaster-like substance) remained the mainstay of smaller farm buildings in most nations. In the Austria-Hungarian provinces of Galicia and Bukovyna wood resources dominated barnyard construction, a tradition easily re-established in Western Canadian regions settled by Ukrainian people. Recognized styles prior to immigration included horizontal log construction and frame-and-fill, a method useful in areas where good timber was too costly or unavailable. As well, the centuries-old shelter traditions of the Hutsul shepherds in the Carpathian highlands came to practical use in the early settlement of prairie farmland through sod-roofed dugouts patterned on the earlier "staya."

Log was also a principal material of Scandinavian farm buildings in both Old and New World surroundings. The earliest recorded Finnish farm dwelling was a medieval four-walled house heated with a stone oven, but with-

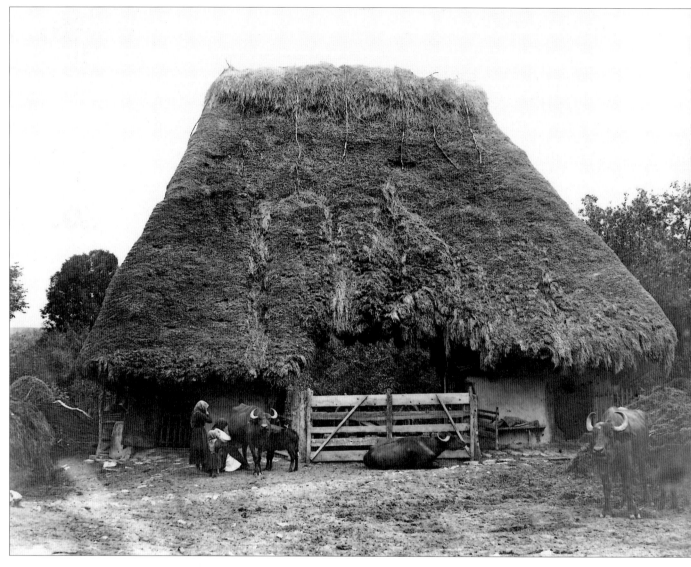

13. Built about 1899, this thatched stable near Nagyvarad, Romania, features a drive-through also used as corral for oxen.

out a chimney. This also served as a threshing barn and sauna, but the form began to disappear in the sixteenth century as each function began to get separate housing to accommodate increasing farm sizes. Cowsheds, stables, granaries, bathhouses, and threshing barns were separated, although in some parts of Finland the custom was to form a closed yard.

The traditional use of log, and of separate buildings—one for cattle and horses, another for small grains and hay—was emulated throughout Europe. Towards the end of the nineteenth century, the mood changed to single multi-purpose barns, usually of frame construc-

tion. Few European farm societies resisted this modern pressure.

In some cases, there was no need to continue old building customs. Icelanders, for example, whose main occupation in Canada would be fishing, found a relative luxury: forests of timber, albeit immature. In their former homes, wood was scarce and most structures were crude fabrications of earth or sod.

Even within countries, styles could differ by region. In Germany, several distinct barn styles could be found through the centuries. In northern regions, the barn was marked by aisles running the length of each building. In the middle

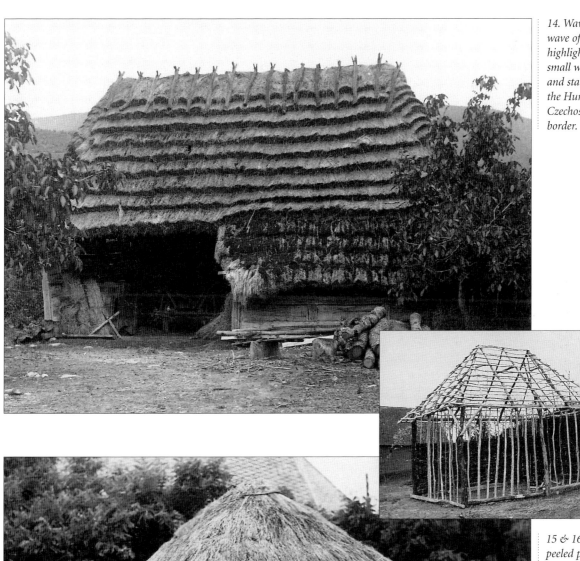

14. *Wave upon wave of thatch highlights this small wagon shed and stable near the Hungary-Czechoslovakia border.*

15 & 16. *The peeled pole framework provides the skeleton for willow sticks to be woven into walls. This can be further weatherproofed by applying daub, a plaster-like substance.*

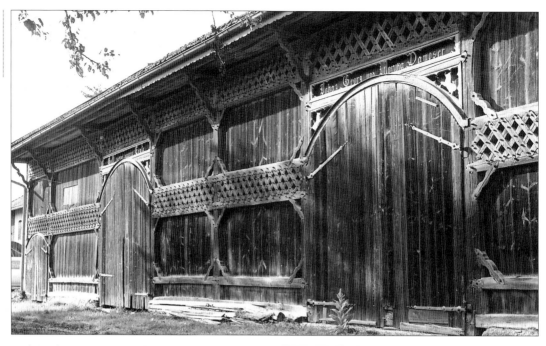

17. Ornate craftsmanship is displayed on a long granary in Upper Austria.

and southern regions, aisles ran the width of the barn.

In the northern styles, two other layouts could be found: the "hallendielenscheune," which featured three rows of interior pillars and often became a combination barn-byre-granary, and the "kubbungdielenscheune," which had only two rows of pillars and remained a basic barn throughout the years. Both styles had doors located in the gable ends, developed mainly from the seventeenth century when threshing floors became a part of barn design. It was about that time that corn began to replace hay as a main livestock feed.

The more southern style was also composed of three distinct work areas, but doors were always in the side walls. This "querdielenscheune"

19. A livestock and hay barn near Oberes, Murtal, Austria.

form was evident from the Middle Ages on, although a second door to provide a passageway for wagons did not materialize until later years. The peasant farmer always stored his harvest in such barns, while also living with the livestock in combination house-byres.

These examples are only a hint of the many European barn customs that found their way into Western Canada. Some styles were transported intact as immigrants attempted to recreate familiar structures in new and sometimes hostile surroundings. In other cases, only small aspects of old traditions were reproduced. In all, they helped create a showcase of barn forms unique in the world.

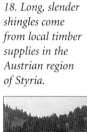

18. Long, slender shingles come from local timber supplies in the Austrian region of Styria.

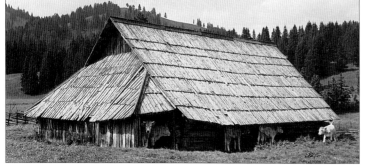

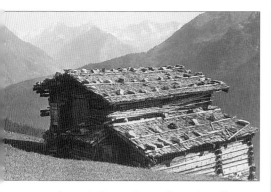

20. An interesting configuration of log lean-tos and sheds in Tyrolia, Austria.

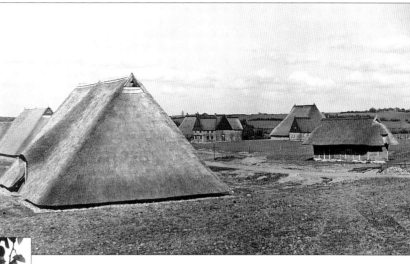

21. An example of the enormous housebarns of Germany, this one at Bauernhausmuseum.

22. A large farmstead of thatch roofs, all preserved at Schleswig-Holsteinisches Museum in Germany.

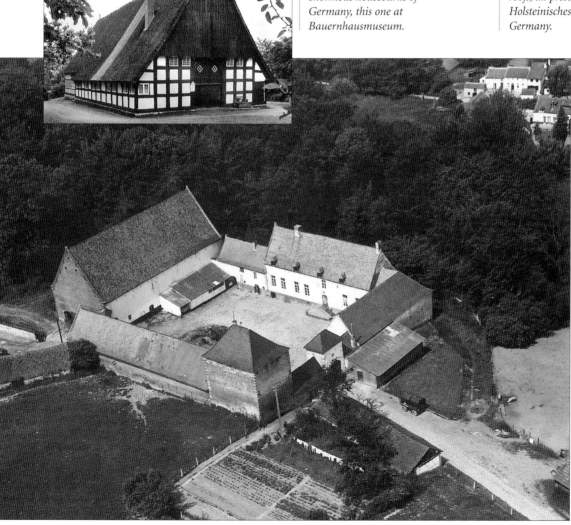

23. The farmyard is enclosed in this typical eighteenth-century layout near Roux-Miroir, Belgium.

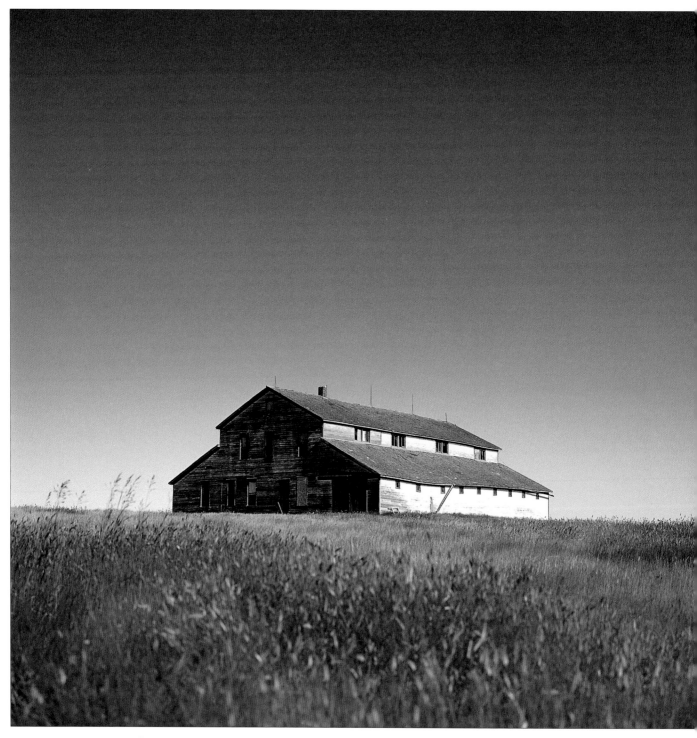

24. "Noah's Ark"
near Weyburn,
Saskatchewan.

Cultural Signposts

They once stood on almost every quarter-section of hard-won prairie farmland; on almost every block of every city and town in Western Canada. Like signposts leading out of the nineteenth century and deep into the present, barns signalled the change from a West dominated by fur trading concerns and lifestyles. They reflected the three-way settlement of the west: the flow of farmers resettling from Eastern Canada; the direct migration from Europe; and the influx of agriculturists from the United States.

In earlier times barns also brought old or new communities together. First, there were thousands of communal barn-raising bees that symbolized the spirit of co-operation and the strength of isolated settlements. These same buildings provided the earliest meeting places for farmers who wanted a better deal from governments. They provided the biggest and best places for rural dances during the first four and five decades of this century, perhaps a reason for the romantic links with "the little red barn."

There are only a handful of images that best represent Western Canada to the world: vast, unending horizons of grain fields and rolling pasturelands; tall grain elevators silhouetted against two-hour sunsets; huge monoliths called barns, reflecting a scale of agriculture unchallenged in the world. Yet we emphasize city clothes and manners, polishing too hard an image in an attempt to gloss over the reality of manure stains.

Today, barns in Western Canada hold little

> *Those who continue to build barns as they did before, are most of them only burdening themselves with inevitable debt. The love that we give to the romantic barn is given to a departed spirit whose image lingers on.*
>
> MARY MIX-FOLEY,
> ARCHITECTURAL FORUM

significance for generations that are once, twice, and thrice removed from the land. Although currently numbering more than 200,000, barns are disappearing at a frightening rate. And instead of alarms being raised and action taken, society continues to direct already meagre handouts for heritage preservation towards symbols of urban commerce or power. The public imagination has too easily been captured by city architecture copied from another place and time, certainly not inspired by Western Canada.

Merging Worlds

If the New World were to be settled, it would need sturdy barns to see new settlers through the harsh winters. Champlain knew what he wanted: new stables for the crowded settlement, a main stable being "60 feet long and 20 feet

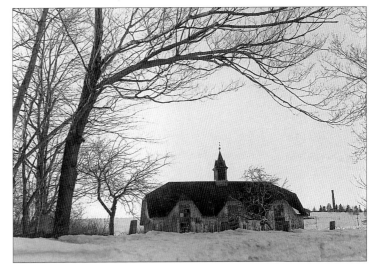

25. Hipped dormer-gables near L'Ange-Gardien, Quebec.

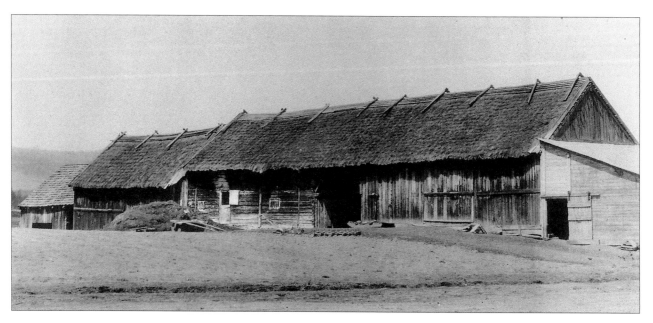

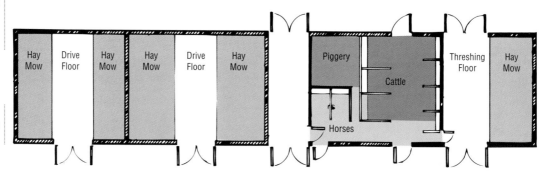

26. A long, thatched barn near Baie St. Paul in the early part of this century.

27. The floor plan for a typical Quebec long barn.

| Hay Mow | Drive Floor | Hay Mow | Hay Mow | Drive Floor | Hay Mow |
| Piggery | Cattle | Horses | Threshing Floor | Hay Mow |

wide, made of wood and earth, like those in the villages of Normandy." Smaller barns would also be built, using techniques of old Europe, gasparade, or the cob and daub that featured an earthy plaster over a wall of woven and pinned sticks.

Long after the first farm was started in Canada in 1615 (and even into this century) the same techniques were still popular in eastern regions. In what became Quebec, two main styles were used: the Normandy and Breton models. In what now is Ontario, log was the dominant material, with building styles haphazard and temporary.

The Normandy layout in Quebec featured a U-shaped or courtyard form around which the different farm functions were assigned to differ-

ent buildings. The Breton tradition is said to have represented the poorer farmer class, with the long, thatched stone building sheltering animals and the farm family, and providing room for threshing and food storage. One of its most pronounced features was a large dormer that initially served as the main entrance to the loft and became more prominent as the style evolved in Quebec. The Breton model, or "maison bloc," began to lose popularity by the 1800s as farmers started building separate dwellings for their families, but kept barn, stables, and work sheds in long, continuous buildings.

The Normandy model, or "maison cour," evolved into a style of farm architecture more adaptable to new conditions. In many other provinces, including the Maritimes, its chief

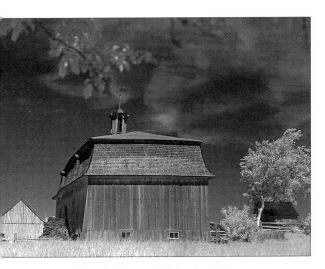

28. Vertical siding and distinctive bell-cast mansard roof at L'Islet, Quebec.

Piève-sur-pièce appears to have been the preferred method of barn construction, whereby planks or squared logs were tapered on the ends to fit into grooved vertical posts. This method allowed easy expansion and redesign as farm conditions changed. Other methods included palisade or sheathing, the former made of vertical posts driven into the ground or set on wooden planks.

All these methods found their way westward. Small by western standards, these Quebec models averaged 20 feet by 30 feet, although some reached lengths of up to 50 feet. The early barn roofs were thatched with straw or hay, although farmers considered the material inferior to Old World flax materials. Cedar shingles and a form of planking similar to board-and-batten methods soon replaced thatch roofs.

characteristic of separate buildings for various farm functions was simply broadened to form an informal courtyard.

One of the most notable features of early Quebec building was the detailed official record-keeping. This, along with the excellent research done by R.L. Seguin for his National Museum of Canada publication, *Les Granges du Québec*, gives an accurate picture of farm buildings in the different periods of early Canadian history.

A principal material was wood, even though stone was readily available and used frequently and attractively for residences and business.

According to the Architectural Conservancy of Ontario, farm buildings in Upper Canada were subject to three specific stages of development: pioneer period, wheat period, and mixed farming stage. Almost all pioneer barns were initially of log, either as unpeeled poles or dressed on two sides with broad axe and adze. Farmers were encouraged to replace these early efforts with frame barns as quickly as possible, notably in the early and mid-nineteenth century during the wheat boom. It also brought the need for larger barns to combine the function of animal shelter, grain storage, and threshing.

29. A round barn with a difference— wooden ramps serving two of the top three levels. Located at Barford, Quebec.

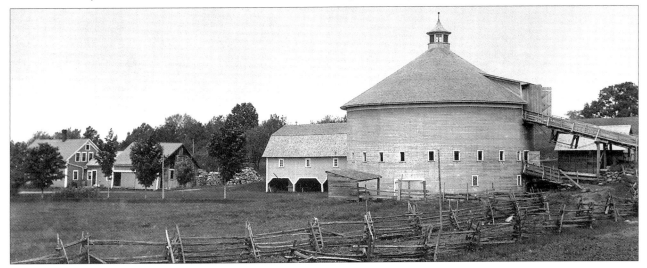

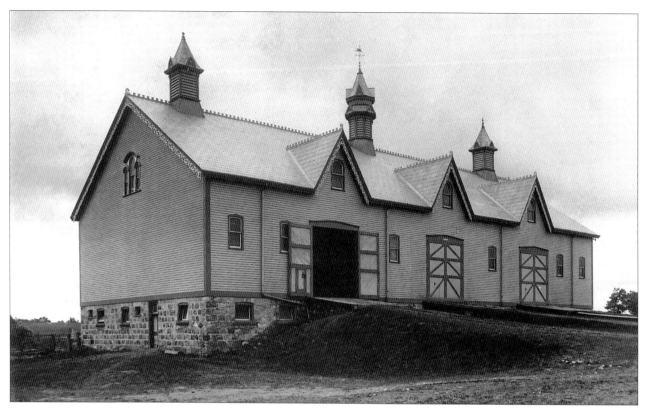

One of the earliest barn forms was the three-bay, or English barn, as it was known in the North American colonies. It was easily built of log, frame, or stone. Its design of two storage bays separated by a central threshing or storage area lent itself to many scales of farm size, including the conversion of one bay to livestock when needed. Sometimes a crude loft was formed by laying poles above the mows or storage areas. As long as agricultural operations remained relatively static or small, the three-bay barn provided ideal shelter.

The bank barn was one style that evolved from agricultural expansion, the Pennsylvania style being one of the earliest and perhaps best-known examples. Livestock occupied the lower floor and feed was kept in an upper storey that was usually accessed by a small ramp from the side of a hill. Descendants of early Mennonite and Pennsylvania German settlers came to Ontario between 1795 and 1820, settling mainly around the Niagara Peninsula, Welland, York, and Waterloo Counties. Some of these barns were up to 60 feet by 100 feet in size, although the average was somewhat smaller. So popular was this style of building that many owners of three-bay barns simply raised their existing buildings onto a stable wall foundation.

In the evolution to mixed farming a hybrid barn form came into being, labelled the Central Ontario barn by barn researchers. It retained the features of a bank barn without a bank, and instead had man-made ramps leading to second-level wagon doors. Siding was vertical plank, often up to 15 inches in width. As more effective

30. A visual delight with its three separate ramps, dormers, and cupolas, plus an unusual amount of fancy trims and gingerboard seen in various plan books.

31. The three-bay barn floor layout of a typical Ontario log barn or early English barn.

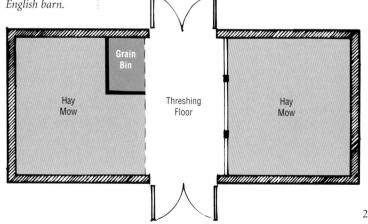

ventilating systems came into the market, this vertical siding was made weathertight by battens nailed over spaces between each board.

As in Canada, the earliest barns in the United States were attempted imitations of what pioneers had left behind. Steep roofs for thatch, low side walls, and separate buildings and functions were characteristic of the 1600s. During the next century, barns began to develop a shape more distinctive to North American farmyards, which in another one hundred years would be exported to the European areas that had provided their forerunners. More farm tasks would be combined in the newer barns when a second or third storey was added. Roof inclines moderated as milled lumber allowed newer framing techniques. And last, but perhaps as important as any other factor, farmers began to view barns as public displays of their own agricultural success.

Two early barn types that hold more direct links for Canadians are the bank barns of Pennsylvania and the Dutch barns of New York State. The Dutch barns were built by immigrants who were among the very first settlers to

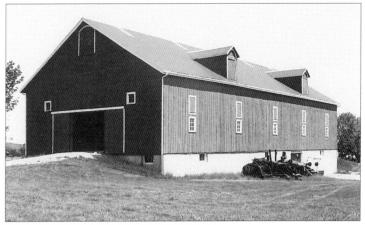

the coastal region, and who became much admired as productive farmers. Their barn structures were practical and readily adapted by new farmers who had passed through the region on their way to other parts of the continent.

Made of all-wood construction, the Dutch barns had wagon doors located in each gable end, unlike many other barn types of that era that featured wagon doors in side walls. Generally single-storey structures, they had a steep roof and thus a voluminous loft area for

32. This end-drive barn came from a predominantly Scottish enclave of central Ontario. Built in 1882, it now is part of the Ontario Agriculture Museum at Milton.

33. Vertical siding on a row of barns near Grande Pré, Nova Scotia.

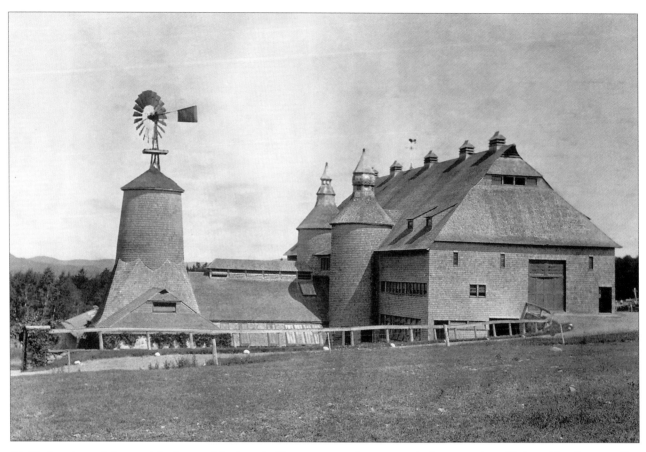

34. The largest barn in the Maritimes, built by Sir William Van Horne at his Covenhaven farm near St. Andrews, New Brunswick.

35. One of the most easterly barns, a turn-of-the-century photo of the stone barn at Middle Cove, Newfoundland.

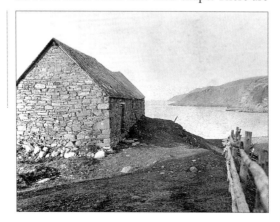

hay and feed materials. A typical barn was nearly square, each wall measuring between 40 and 50 feet.

Some barn experts consider the Pennsylvania barn a wholly American creation, although its origin might derive from several European countries. It is most often thought of as "the" original bank barn in this continent, from which all other bank barns take their shape. There are several features that distinguish these earlier models from later versions.

The first bank barns almost always featured an extended forebay. As the availability of prime forest materials declined, the cantilevered mow floor slowly disappeared until a small shed roof, or pentroof, provided token protection from driving weather. In Pennsylvania, the end walls were almost always brick or stone, whereas in Ontario and other Canadian provinces the entire structure was wood set upon a stone foundation. Unlike its European ancestors, the North American model often had a side wall dug into a convenient south-facing incline, as opposed to the Old Country style of a gable wall butted into a hill.

One American farm form that generally stayed within its original geographic boundaries was the connected farm buildings of New England states. Built to give assured access to farm chores in heavy weather, the idea did not

gain wide acceptance elsewhere. Temporarily banned in the 1600s because of the proven danger of fire destroying entire farms, the popularity continued for some time and could include as many as ten or twelve buildings joined together.

Other styles said to have originated in the United States and spread elsewhere might include circular barns and tidewater tobacco barns. The high-peaked tobacco barns took their lines from early European influence, and depending on the geographic location, provided unusual flexibility. In the south, for example, tobacco leaves were cured by heat and square log barn walls were therefore tightly fitted. In Connecticut the cigar leaf was air-dried and barns had moveable exterior panels to allow air circulation. Maryland tobacco farmers also required air-drying, but simply did not apply exterior siding.

The nineteenth century was a major turning point in barn development and the period provided most of the changes in design and materials that we see today in Western Canadian farm buildings. Part of the change was brought about by the increasing activity of agricultural educators and newspaper writers, who constantly promoted concepts of farm labour efficiency and economy of space.

These forces are best illustrated by a book of barn plans published more than one hundred years ago by the managing editor of the *American Agriculturist*. An Ohio barn was put forward as a 60-foot-by-24-foot bank barn, with improved ventilation to satisfy critics who had complained of the lack of this feature in earlier bank barns. The cost of $1,200 seemed proper for a two-level barn. A Missouri barn appears to have been 80 feet square, and to have cost about $9,000. Its distinctive shape was often called a monitor design, which apparently resulted from smaller lean-tos added to each side of an end-drive barn. This barn had eighty-four livestock stalls and was obviously designed for a large farm operation.

A "small, cheap" barn was offered in 1880 for budgets of $300 to $350. It provided a 6-foot loft, three animal stalls, and three bins of ten to fifty bushels each. It also allowed animals to be fed from the front, "which is often desirable, as in families having no hired help, the feeding is sometimes entrusted to children."

For farmers just starting out, experts suggested a shelter cost of $15 per animal for shed-type barns.

Whether the western farmer sent for exact plans, adapted his own plan from pictures, or followed styles remembered from trips east, ideas promoted in books and farm newspapers became the standards for what we see today.

New Homelands

Bert Henchbaugh had heard some hair-raising horror stories about killer blizzards that blanketed long winter months on Canada's western flatlands. Living south of Chicago, he had heard how western farmers sometimes tied rope from the house to the barn in order to feed livestock and return safely during such storms.

He came anyway, building in 1906 a unique farm structure (No. 24) northwest of Weyburn, Saskatchewan. He and his building are typical examples of how different cultures and materials merged in a new homeland. The local people called it "Noah's Ark," an apt reference to man

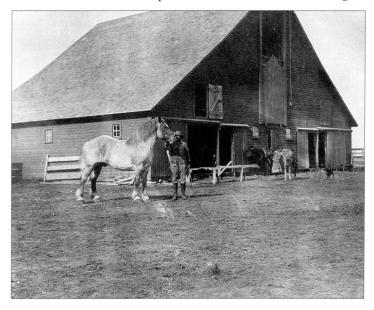

36. This barn at Reed Ranch near Olds, Alberta, with its low side walls, end-drive entrances, and long, high loft lines reflects an awareness of the New York barn design.

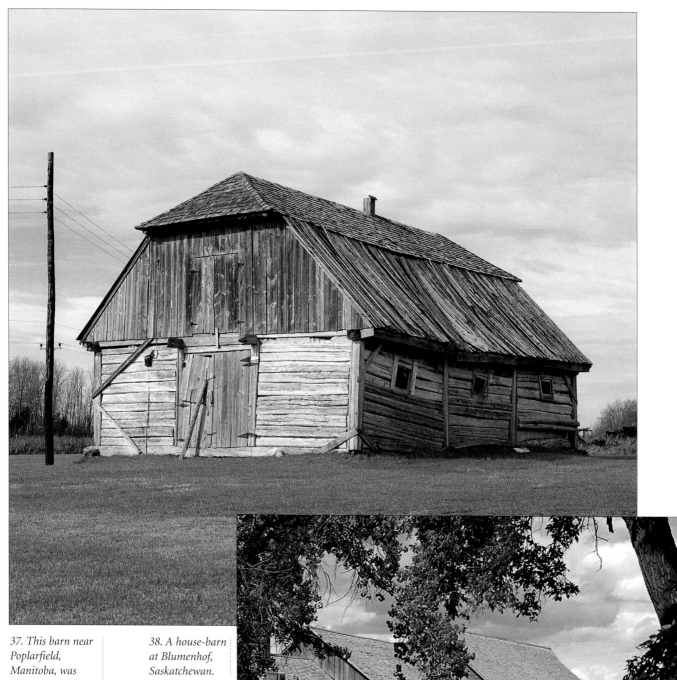

37. This barn near Poplarfield, Manitoba, was built with a unique board and batten style of roof covering, plus the Red River frame or post-and-fill style of log wall construction.

38. A house-barn at Blumenhof, Saskatchewan.

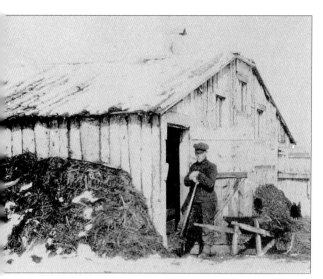

39. Icelandic settlers did not transfer many building designs from their homelands although they quickly adopted lessons of the new land, including the example at New Iceland of piling manure against walls to freeze and lessen the effect of chilling winds.

and his animals being able to wait out the worst disasters imaginable.

Henchbaugh was one of an estimated one million Americans who tried to till the soils of Western Canada during the settlement era. Also, he had money with which to start his new farm. Finally, he had close family roots in Europe where farm buildings had been constructed in traditional styles for centuries. His new house-barn reflected these diverse influences, including the old style of livestock and farm family sharing the same roof — but this time in style and comfort.

The front of the Henchbaugh house-barn was given to three-storey living quarters. All rooms on the ground level were twenty feet wide and provided access to the barn, which was divided into separate areas for horses, cattle, and feed storage. The barn portion was built on a concrete floor, and two large basement cisterns provided water for man and beast. Other features of this house-barn reduced the impact of winter blizzards, including the region's first electrical lighting system with generator, plus a pool table to help battle the blahs of winter isolation.

The Henchbaugh place certainly was not a

typical farm setup at the time, but it did typify the flair and innovation with which the wealthier settlers set about putting down roots.

A much larger number of settlers came in near poverty, but left an equally indelible imprint through building customs and designs that were centuries old. In total, more than thirty distinct ethnic groups were represented in settlements in four western provinces—some thinly spread across the plains, others concentrated in their own exclusive communities.

Traditional and cheap building methods were the only alternative for many farmers. A federal government survey in 1931 found that the average capital of settlers had increased substantially from 1900, but that settlers from European countries had been extremely poor in compari-

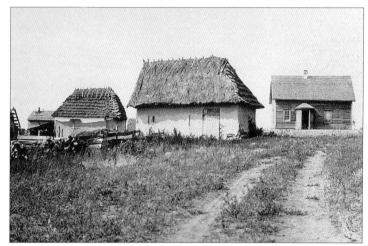

40. The original log and thatch house was turned into a second barn when the farmer was able to purchase milled lumber for a residence.

son to neighbors who had immigrated from the United States or Eastern Canada. Prior to 1900, the average starting capital per farmer was $357, while in 1905 it had jumped to $1,250. Between 1925 and 1930, the average capital for starting a farm had risen to $5,000. In areas where farmers had immigrated directly to the West, the original capital was one-third to one-fifth that of settlers who had come from the eastern states or provinces.

Several ethnic groups, including Ukrainians, Scandinavians, Dutch, and Germans, transferred distinct building traditions to their new farm homes and farm shelters. Others such as Icelanders, French, or Italians transferred little

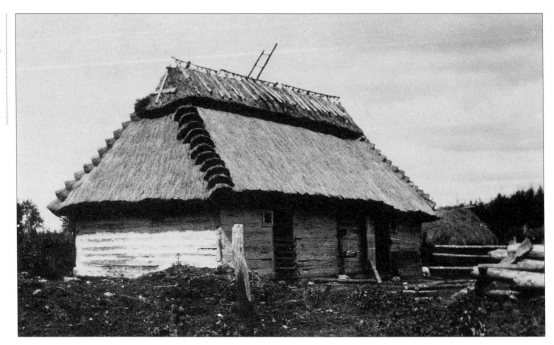

41. Built at the turn of the century at Foley, Manitoba, this barn featured a distinctive thatched roof and well-chinked log walls.

from previous homelands. For the former groups, life on the prairies frequently began in a sod structure dug into the black earth or at ground level. As financial abilities improved, these settlers moved to more permanent homes and began building substantial shelters for livestock and feed. At the same time, thatched roofs disappeared from the house and barn. Today, very little evidence remains of these first- and second-stage structures.

Norwegian settlers are credited in early farm journals with introducing the soddie to prairie agriculture, a building material and technique they had perfected in Wisconsin and Minnesota before moving on to Western Canada. Each sod was normally two feet in width and three inches thick, recognized today as near perfect insulation material for harsh winters. The price was right, of course, and one enthusiastic newspaper reporter suggested in 1900 that there were as many sod churches on the Great Plains as there were barns or huts.

Other variations to the soddie were offered by the Mennonites, who introduced a Russian semlin to early settlements. Built several feet into the ground, the roof featured a three-layered recipe of split oak planks plastered with clay, then cov-ered again with sod. The Ukrainian settler offered still another version of the sod building, an adaptation of the staya dugout used by Carpathian highland shepherds.

Of the many ethnic traditions to thrive in Western Canada, those of the Ukrainians and Mennonites have perhaps been most thoroughly researched and preserved. New Ukrainian farmers preferred horizontal log structures when timber of sufficient length and width was available. Otherwise, they would use vertical log (stockade walling) or frame-and-fill construction. The horizontal design utilized both saddle-notching and dovetailing of logs for corner joinery, although more intricate dovetailing was reserved mainly for logs that had been squared on at least two sides.

The frame-and-fill method was also called Red River frame after techniques used by early Métis or French-Canadian builders. It was frequently found in areas of poor quality timber. In southeastern Manitoba, for example, a great many structures were built this way, with better timber used for vertical main framing, and logs of poorer quality cut into the short pieces to be fitted horizontally in the grooved framing logs. The entire wall was then covered with a

type of plaster made of mud, straw, and lime.

Vertical log construction was also found in areas of poor timber. For animal shelters, this simply implied driving sharpened logs into the ground. Early rot and twisting walls made this technique the least attractive of the three alternatives. Studies in Alberta suggest that timber resources there allowed Ukrainian settlers to use horizontal-style construction, whereas immigrants from the same area in western Ukraine who settled in southeastern Manitoba had to use vertical or frame-and-fill techniques because good timber was unavailable.

Mennonite settlers also built distinctive farm buildings in Manitoba, Saskatchewan, and Alberta. The earliest and largest building activity took place in southern Manitoba and Saskatchewan, where more than one hundred house-barn combinations still exist.

This unique type of structure dates back to the Netherlands during the 1700s. The earliest examples were built at Danzig, where frequent flooding compelled Mennonites to build raised mounds on which to locate barn and house, which soon were joined for economy, warmth, and the protection of animals.

In Western Canada, the barn portion of the building is the farthest from the front of the property, while the barn roof is often about two feet higher than that of the house. A feature of most Mennonite barns is the long row of small windows usually located over the main entrance. Originally, almost all house-barn exteriors were left unpainted or unprotected against the extreme Canadian climate. The first colony leaders believed the painting of buildings was too individualistic and unnecessary, and it was banned for many years.

Earliest Mennonite buildings utilized the slough grass thatch roofs similar to other European styles. This material was quickly abandoned because of fear of fire, but also because the relatively quick farming success of this group allowed the replacement of thatch with cedar shingles.

Scandinavian farm structures were mostly noted for their excellent log construction. Finns, Swedes, and Norwegians all utilized tight dovetailing lap or lock-notch corners and hand-hewn horizontal design, proven durable by the large numbers of surviving log structures. Most barns were relatively small in overall dimensions—stables, really. The drive-through stable or granary was a popular design.

Doukhobor farm buildings were unique barn silhouettes against the western skyline. They originally featured hip roofs with enormous overhangs of up to three and four feet. Settling first in Saskatchewan, then extending to British Columbia, and finally to Alberta, this tightly knit Russian religious sect started with only one or two large log or sod barns in each Saskatchewan village. These would serve the entire community. By the time the second and third uprooting had taken place, thatch roofs and indigenous materials were left behind for modern frame or brick structures. As well, individual Doukhobor farmers had acquired their own barns and operations.

Architectural historians have frequently noted the persistence of the past in frontier designs, or a determination to reproduce a familiar and secure environment in what might be considered a hostile land. In Western Canada, this lasted only as long as financial conditions required. Most Old Country building traditions then were assimilated by modern styles that claimed no parentage except convenience.

Barnlore and Romance

About 130 men and women from the Balmoral area of Manitoba gathered to help a neighbour on a warm June morning in 1906. By suppertime Sam Sims had a half-completed barn, the result of a community tradition that is regarded as a hallmark of early settler co-operation.

Barn-raising bees have become firmly entrenched in romantic barnlore, alongside images of the "old red barn," the Saturday barn dance, or ol' Nel and Gert resting quietly in horse stalls before going back to work the fields the following day. Not surprisingly, there are

equal parts fact and fiction mixed with each image.

The Sam Sim barn raising was typical, although bees were not as common in the West as many might believe. A local newspaper, the *Stonewall Argus*, found the Sims gathering worth reporting:

> Some twenty-four gathered in the forenoon and assisted in placing the timbers. They were all sorted out and the bents placed together, so by three o'clock the actual work of raising the frame was

this precarious perch, they steered his wife away to the other side of the house. She was soon to deliver a babe but they didn't want it to arrive then.

While this particular raising ended on a happy note, other chronicles of the day were filled with reports of death or serious injury resulting from barn bee accidents. At that time, new barn activity in Eastern Canada was almost non-existent and construction crews headed west looking for work. Paying $20 for a manager and four-man crew to erect the main frame was not an unrea-

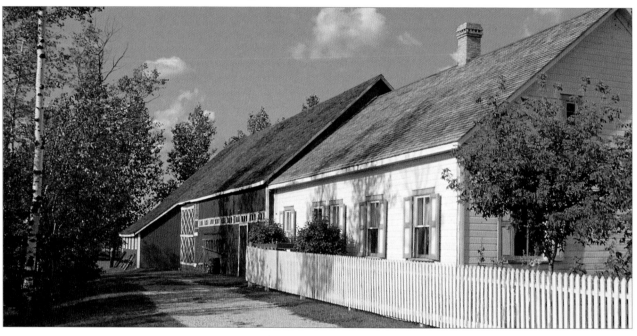

42. One of the best maintained examples of the house-barn is found at the Mennonite Pioneer Village at Steinbach, Manitoba.

ready to begin. Some people think that Manitobans are green goods when it comes to barn raising, but by six o'clock the work was done, and the barn being no small one, being 80 feet by 40 feet, 12 foot side posts on a nine foot stone wall.

Did every one of the 130 people eventually pitch in? The newspaper account provided strong evidence:

> One of the helpers on the barn was Joel Willson, who worked on the high peak. When some of the ladies saw him up on

sonable price considering the safety factor as well as the cost of feeding a small army of "volunteers." One man worked the team of horses and derrick pole for raising timbers, while the balance of the crew worked at joining and pegging.

Another factor weighing against barn raisings was the decline of large-timbered frames early in the century. Local timbers were no longer of sufficient size or length and, as in the Sims case, main frames often had to be railed in from British Columbia.

The consequences seem obvious today. But even in 1906 the loss of barn bees was regarded

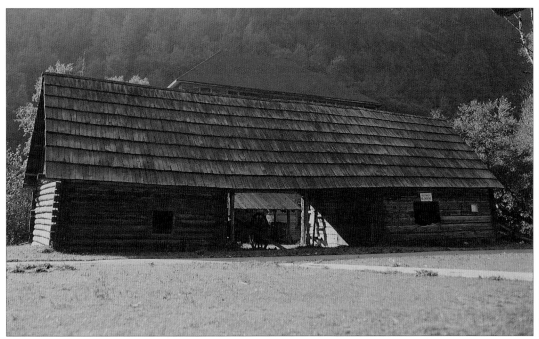

43. Finnish immigrants were in great demand by the railways because of their ability to build enormous log trestle bridges across deep gorges or mountain rivers. Many left to start farming and built barns like this drive-through design at Three Valley Gap, British Columbia.

44. Twin silos grace this bright red barn at Broomhill, Manitoba.

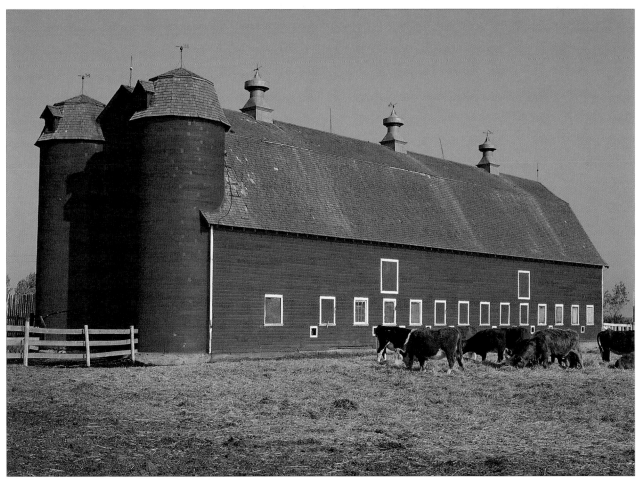

45. About 165 neighbors are pictured near Pense, Saskatchewan, at the major social event of a barn raising.

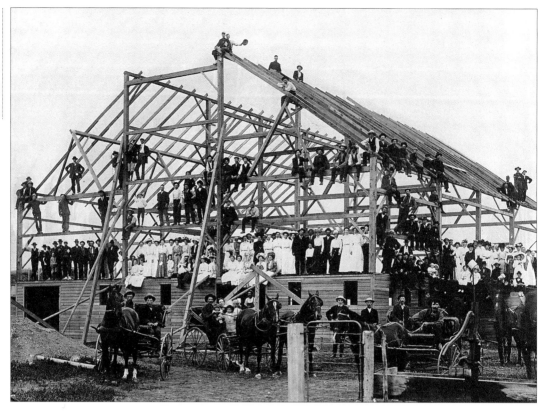

as too high a social cost of progress. At the same time the Sims barn was being erected, a leading western farm weekly newspaper was lamenting the decline in popularity of the bee. An unknown *Farmer's Advocate* editorialist complained:

> Barn building was not simply a measure of the material progress of a community but offered opportunity for social climaxes that often fixed the destinies of families, townships, counties, and often of the provinces and states. But shorn today is barn building of all the romance and glamour of the early times.

Fortunately, it was not a total loss on the social front. The tradition of hosting a huge community dance in a newly completed barn is carried on in Western Canada even today. Also, two or three barns in each community were usually available for regular barn dances, social events generally open to all ages. The advent of com-

munity halls in the 1940s and 1950s finally silenced the old barn dance—another example of progress and convenience displacing community traditions.

The question of colour may seem a silly one to modern-day viewers, but it wasn't until well into the present century that coloured barns, red or otherwise, made a general appearance on the prairies.

There was plenty of early advice from leading farm journals and their advertisers. As well, farmers wrote long and thoughtful letters on such subjects, sharing ideas for less expensive and perhaps superior paint formulas. As early as 1870, Sherwin-Williams Paints in Montreal was asking western farmers to send a sketch or photograph of their farmyards and receive in return an artist's coloured concept and colour cards for suggested exterior decorating. By 1890, stories were appearing in farm papers almost weekly quoting expert chemists, who were usually on the staff of major paint advertisers. For example, one rather blatant opportunist declared,

"Owing to properties of iron in paints, buildings stood up to heat, rain and frost for 300 years."

Farmers themselves appeared to prefer two main colours—white and red. While the red barn came to dominate farmscapes, white had a more popular following in the early days, particularly in regions where settlers used masonry or plaster-type covering of exterior walls. In Ukrainian settlements, white with either blue or green trim quickly identified the farmer's homeland and original place of birth.

Why the red barn? The question has been offered a thousand plausible but different explanations. Did the railways' use of various reds make their commercial production less expensive than other colours? Or did the combined usage of railways and grain companies simply get extended to the farm? Perhaps the colour became a cultural tradition through early berry stains and protective materials used by North America's Native peoples or first settlers. Perhaps red barns are simply more pleasing to the eye.

In Western Canada, part of the answer appears to be the ready availability of iron oxide to mix with linseed oil. This five-pound-to-one-gallon recipe was known to every farmer, and it is believed to have been the simplest and most popular homemade paint in the early West.

Other home-made recipes were slightly more complex. For example, one farmer offered an 1897 concoction for whitewash in an open letter to readers:

> Slake half a bushel of quicklime with boiling water, keeping it covered during the process. Strain it, and add a peck of salt dissolved in warm water; three pounds of ground rice put into boiling water and boiled to a thin paste; half a pound of powdered Spanish whiting and a pound of clean glue; dissolved in warm water; mix these well together and let the mixture stand for several days.

Put it on as hot as possible, concluded this farmer.

For farmers with new but extremely rough lumber, or old, weathered fences and barns, another farmer suggested an alternative recipe. Put two bushels of fresh limestone into a watertight barrel and sufficient hot water to slack it. Stir in 25 pounds of beef tallow fat. Colouring could be added to produce a cream, pink, or buff tint, depending on the ochre or Venetian Red bases that could be store-purchased for 50 to 75 cents.

While no one argued against the effectiveness of these homemade paints, there were frequent complaints about hostile odors, and thus they were eventually replaced by more convenient store-bought products.

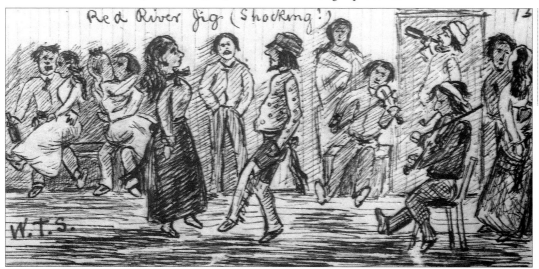

46. W.T. Sabel sketched this scene between 1875 and 1880, showing a Red River jig being enjoyed at a local barn dance.

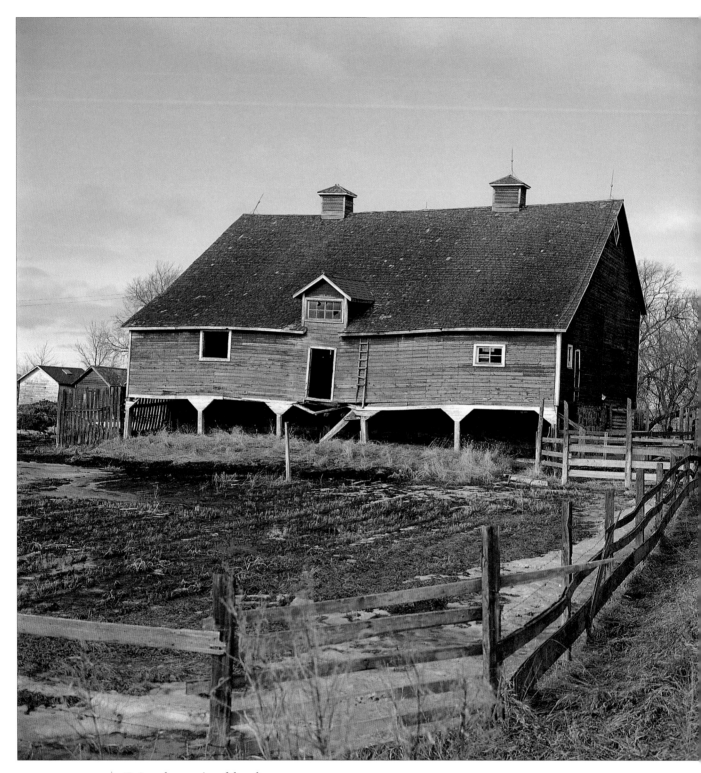

47. *A modern version of the salt-box design at Neepawa, Manitoba, with cattle doors and yard located on warmer south walls.*

Shapes of Heritage

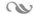

At one time a person could have travelled through different regions of Europe or eastern parts of North America and found within each area many barns of similar design and detail. This would be nearly impossible in Western Canada, where great diversity of shape and size is the most consistent feature of the farmyard. This diversity tells of the enormous differences in size of operations, or the wide range of commodities produced. Often, the shape of barns is not definable, the result of add-ons, alterations, or deletions forced by roller-coaster farm markets.

A strange paradox of western barn hunting is that despite its foundation in western heritage, there is not a "Western Canada" barn form to be recognized apart from others. Barn fanciers can almost instantly recognize a New York Dutch shape barn, a Pennsylvania German barn, an Ontario barn, or U-shaped farm building of Quebec or New England. But no Manitoba barn. No Saskatchewan barn. No Alberta barn. No British Columbia barn. Just an array of shapes and forms adapted through ingenuity and individuality.

There are obvious shapes to arrest the interest of any traveller, however. For example, the round barn stands apart from others, telling us the original owner was a progressive fellow in his time, usually with close ties to American agriculture. A steeply pitched roof tells us the owner either came from an area of heavy snow-

> *The searcher will look in his travels; not for classic columns, cymas or resersa, cavettos, dentils and the rest, but rather for things at first sight mundane: the cantilevered mow, the location of the wagon doors, the height of the eaves, the size of boards, the many secrets hidden in the timber framing and the pitch, shape, and material of roofs—all of which will tell a story.*
>
> Eric Arthur, *The Barn*

fall or anticipated such winters in Western Canada. The long, low barn signals a dairy operation, while an L-shape or U-shape frequently tells us success came to that farm in many stages, and wings were added as financial conditions allowed.

An arched roof. The saltbox roof line. Large metal cupolas versus ornate wooden ventilation outlets. An extended roof line to accommodate a haysling track. Each gives a hint of the construction period. Other silhouettes such as connected house-barns talk plainly of a European heritage, most often in Mennonite settlements. Wagon passageways dissecting a small barn into two equal sides hint of other cultural backgrounds, while different ornaments or window arrangements tell viewers of other Old World origins.

But while barns proclaim the diversity and

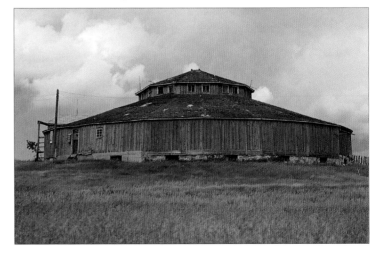

48. The largest round barn in Western Canada at Arcola, Saskatchewan.

ingenuity of early settlers, there are problems for those attempting to preserve the best examples of this heritage. Which styles best reflect historical uses by ranchers and farmers? Is it possible to capture a place and time through only one or two main forms? No, it isn't.

Circular Symbols

After long, hard years of mustang busting and horse trading across the southern regions of Saskatchewan and Alberta, in 1905 Walter Howie built a large circular barn (No. 48) near Willmar, Saskatchewan, that stands as a remarkable building even today. Unfortunately, it also became his memorial.

The barn was a twenty-sided giant that measured 100 feet in diameter. Howie could drive a fully loaded team and wagon around the lower level's wide circular alley, which dissected two rows of stalls. Or he could travel around the 4,800-square-foot upper level where hay and grain were stored. On the lower level, nine horse stalls, twenty cattle stalls, and eight large cow stalls faced a central feed area.

With 4,500 cubic feet of cut stone providing enormous lower walls for the bank-style barn, the roof and floors were supported by large posts—the combination of which offer any viewer the assurance of strength and durability.

For the owner, this assurance proved false. Returning in 1910 from his retirement home in Regina, the former bronco trader was discussing his rental share of an excellent crop then being loaded into bins on the upper level of the barn. A final load proved too much and part of the floor gave way, crushing Howie in an avalanche of barley, wagon, and broken bin.

Whether by coincidence or through association with innovative ideas, owners of circular barns were often colourful and aggressive men with new and ambitious notions. A good example was Major W.R. Bell, who headed the Qu'Appelle Valley Farming Co. Ltd. at Indian Head, Saskatchewan. No new idea was too big or too grand for this 53,000-acre operation, including a round barn (No. 55) that has become a his-

torical landmark for tourists and local citizens.

However, the concept of round barns was born of the minds of quiet, religious men. The design came to Western Canada very late in the nineteenth century, mainly with immigrating farmers from the United States, where Shakers are believed to have built circular forms in the early 1800s. Also popular in Quebec during the 1800s, the circular barn never did gain wide acceptance in the West despite an obvious ability to better "shed" the wind than its box-like counterparts.

An estimated twenty circular barns still exist in the four western provinces, although they take varying shapes from perfect circles, to eight-, ten-, and sixteen-sided structures. Most known examples are in Saskatchewan and remain in good to excellent condition. Without exception, each circular barn has become something of a local attraction, and perhaps for this reason a larger number of circular barns have survived than those of more traditional shape.

But circular barns did not receive top marks from farm commentators during Canada's barn building boom. Writing in a 1914 issue of *Farmer's Advocate and Home Journal*, one of the newspaper's regular design commentators warned farmers away from this type of barn. J.C. Colhart allowed that round barns had two advantages: they required less material to enclose similar areas than did rectangular barns, and if a central silo were incorporated, some feeding efficiencies could result. The editors promoted a new round barn, which they claimed had been built at 22 percent less cost than a comparative rectangular barn.

The largest drawback to such designs was the difficulty of lightingthe central areas. "A round barn to be of any practical use would require to be 50 to 60 feet in diameter, so one can readily see that the light is deficient just where it is most needed," said one expert, adding, "Another disadvantage is the difficulty in constructing a round barn, so as to be at the same time easily ventilated, and yet to be kept symmetrical."

Farmers wanted to have the "proper" facili-

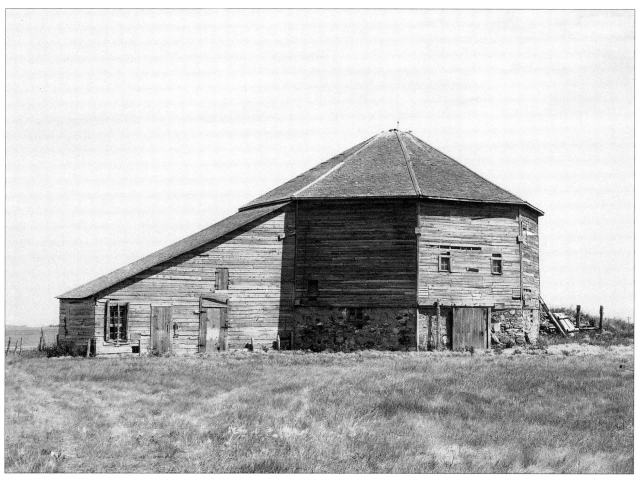

ties, the critic stated. "Picture yourself in a round barn, one storey, say, with an eight- or ten-foot ceiling and a 20-foot silo towering way above it; it seems ridiculous, and every farmer has, or should have, a keen sense of the fitness of things."

Such advice was common and must have hit home because few circular barns were erected. Of the circular barns still in Western Canada, many original owners came from areas in the United States where round barns were well-regarded. Obviously they ignored the Canadian conventional wisdom.

The first round barn in North America is said to have been the great Shaker barn at Hancock, Massachusetts. Measuring about 90 feet in diameter, it is slightly smaller than the Howie barn. Built about 1824, the Shaker barn had to be rebuilt in 1865 and stands in the same condi-

tion today. American farm newspapers fell in love with the then novel design and promoted it enthusiastically. Circular construction was also adopted for other farm buildings such as silos, piggeries, small stables, and hen-houses.

Another argument put forward by some of the round barn's original designers applied more to communal-type farming than to individual or family efforts. Because of the larger scale of storage or shelter required for the popular form of communal farming a century ago, the designers reasoned that a round barn would allow a greater number of workers to go about their respective tasks without interfering in another's work. The logic escapes most modern observers!

A great many of the western circular structures were designed with livestock stalls facing towards the centre of the barn where feeding

49. An octagonal barn and lean-to addition near Elgin, Manitoba.

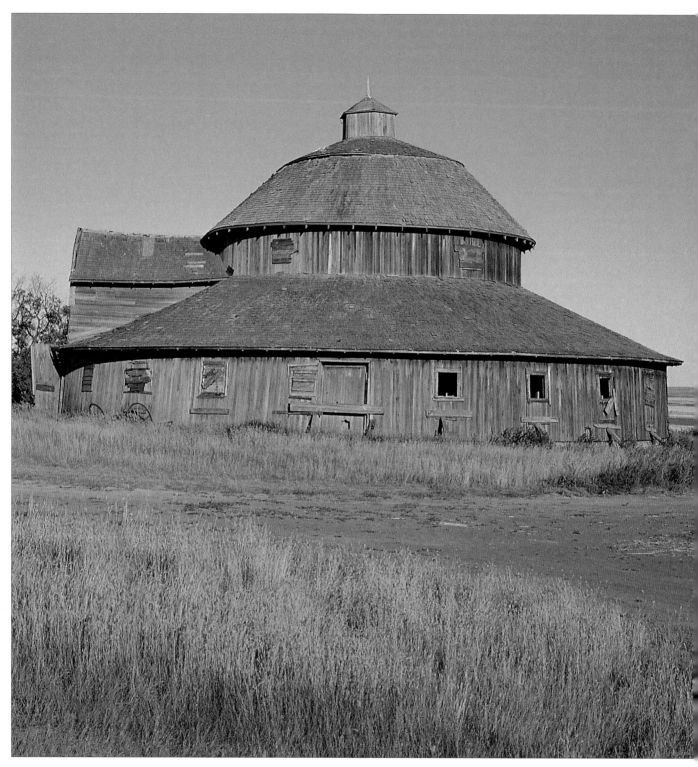

50. The folks near Empress,
Alberta, refer to this grand old
resident as the "Ma Bell" barn
after one of its previous owners.

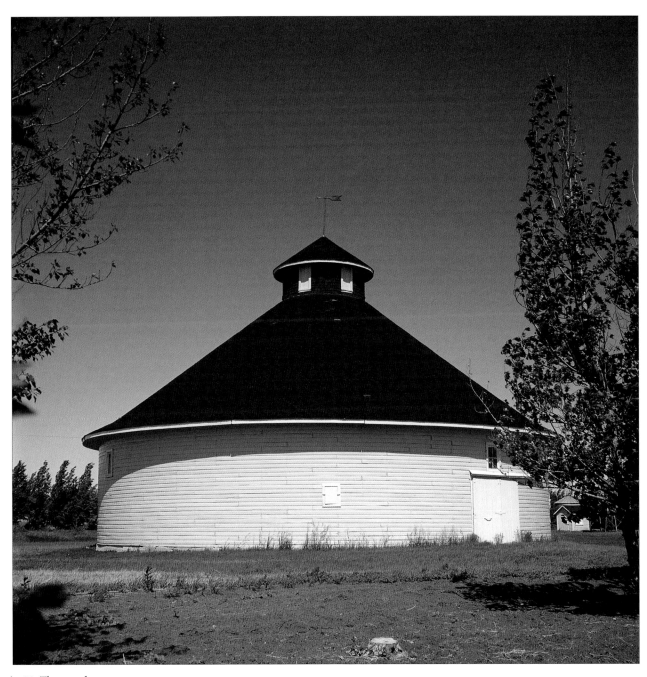

51. The round
cupola peers over
a neatly shingled
roof and painted
exterior at Rouleau,
Saskatchewan.

was more easily facilitated. Some larger structures were actually three-storey designs, with livestock on the lower level, grain bins and storage on the second, and a hayloft on a third level. Like many other prairie barns, they were built on level ground with an earthen or wooden ramp leading to upper levels.

One might have heard another type of argument in support of round barns. The relationship between a farmer, the land, and the church was very strong among the first builders of round barns in America. As well, the Shakers and Quakers were reported to have seen perfection in the circle, a shape found in their furniture, hats, floor coverings, and social and religious gatherings. It is also suggested the round barn kept "the devil from hiding in corners."

Silhouettes of Diversity

To the knowledgeable barn hunter as well as the relative novice, rooflines provide quick clues as to a barn's heritage. Most rooflines popular throughout the nineteenth and twentieth centuries are still around today, as are their various floor plans. For example, the same advice would be heard in the barnyards today as it was fifty, one hundred, or four hundred years ago—"stone to weather, long slopes to north."

The most notable change was the demise of the threshing floor, where crops were once brought to be flailed or winnowed. Mechanization had mostly eliminated this large, central area in barns before a great deal of barn construction took place in Western Canada.

Manure sometimes dictated barn design. A popular U-shaped design, for instance, allowed the farmer to centrally accumulate manure dur-

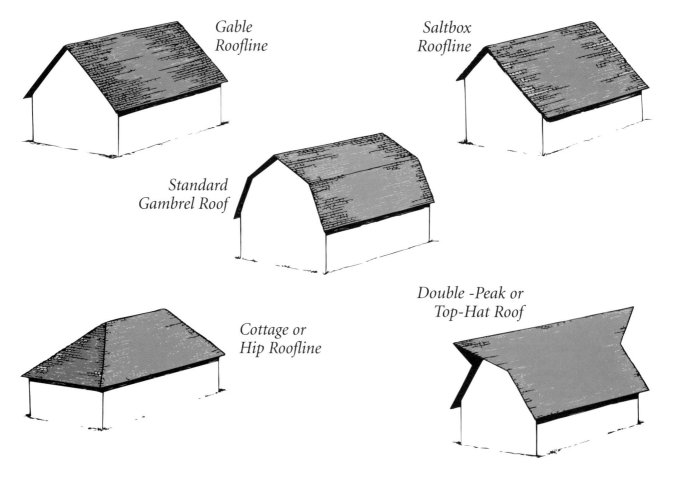

Gable Roofline

Saltbox Roofline

Standard Gambrel Roof

Cottage or Hip Roofline

Double -Peak or Top-Hat Roof

ing the winter and move it quickly to fields just prior to hot weather.

The popularity of the gable end in Western Canada can be credited to its simplicity and versatility in roof pitch—from the relatively modest pitch of small stables, to the steeper inclines of earlier prairie thatch roofs, or the snow-shedding pitch of British Columbia shelters. Also, the gable end was one form easily adapted to mechanization or expansions on the barn and farm. Hayslings, pulleys, and tracks came with a new century and fit easily under extended gable roofs.

The popularity of the gambrel roof soared late in the nineteenth century when enormous new storage loft capacity was required to feed large herds through tough western winters. Instead of the two flat, sloping sides of the gable roof, the gambrel has two slopes on each side

wall to allow full utilization of the entire loft floor. The upper portion of the roof usually possesses a gentler slope, although the pitch is determined by the width of a particular barn. Both gambrel and gable roofs benefited from the introduction of wood and steel truss systems. This innovation early in the new century allowed the farmer to design even bigger barns to house larger herds and feed supplies.

Another form of gable roof is often called the saltbox design. It traces its roots back to early English settlers in eastern North America and is considered by some authorities to be an exclusive North American form. The north-facing slope is most often extended to provide a shed lean-to or low stable.

The hip roof is another popular barn roof, or what many people call a cottage roof. The true hip is a roof with four sides rising at a similar

52. Barn rooflines.

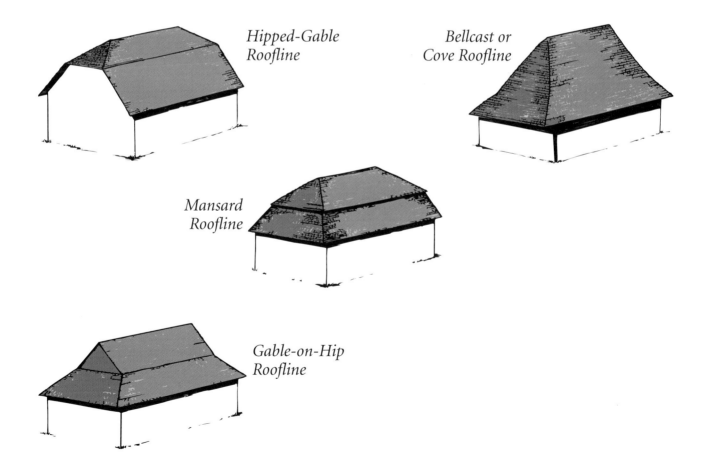

Hipped-Gable Roofline

Bellcast or Cove Roofline

Mansard Roofline

Gable-on-Hip Roofline

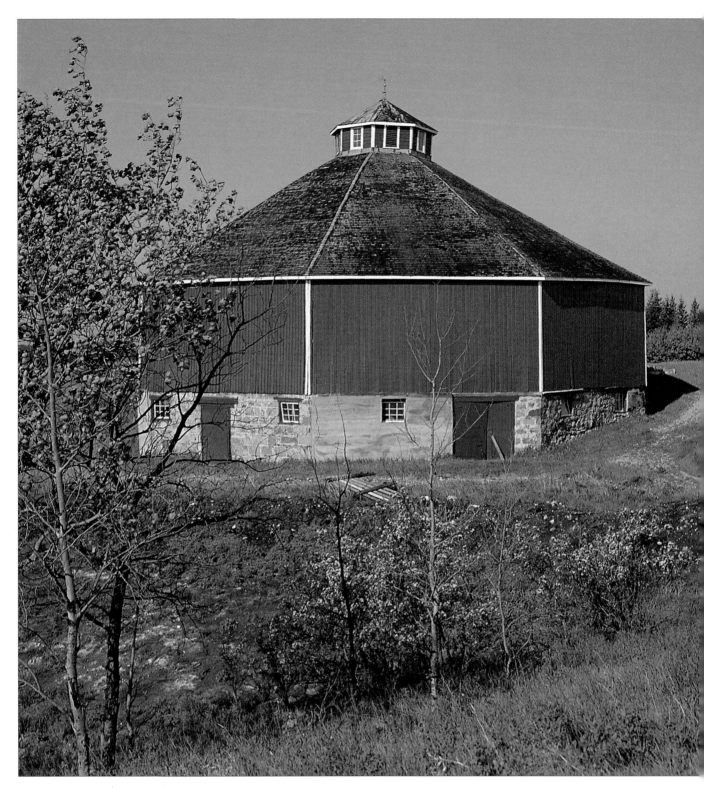

53. *A well-maintained
octagonal bank barn
near Bethany, Manitoba.*

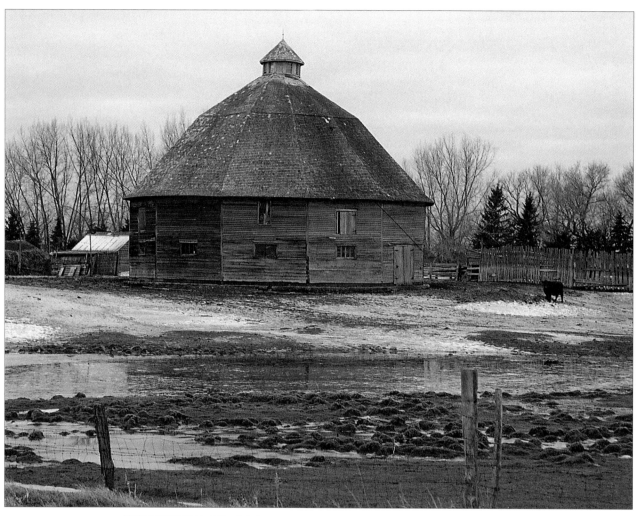

54. A carpenter from the United States built this twelve-sided barn near Macdonald, Manitoba.

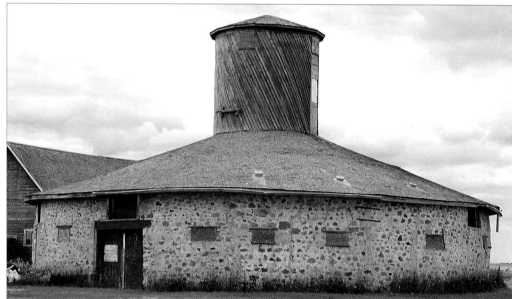

55. This round stone barn at Indian Head, Saskatchewan, is a provincial landmark.

56. The gigantic hay and dairy barns of Delta, British Columbia, are just a cream can's throw from the Pacific Ocean.

angle to meet in a single ridgeline. It was usually gently sloping and not found on barns requiring large storage loft capacity.

Two other shapes proved relatively popular in the West, particularly in barns built after 1910. The monitor design was that of a simple gable-end barn with smaller sheds attached to either side and running the full length of the barn. This design was found most frequently in Alberta and Saskatchewan, although it has been called many different names, including Mississippi barn. It was also one of the few designs that allowed unlimited windows along upper levels and because of this excellent lighting was utilized frequently in commercial barns at stockyards and industrial farms.

The other popular roof outline was really a late arrival in the barn-building era, but one that quickly dominated new buildings on farms and towns. The arched roof relied mainly on laminated lumber to create an enormous storage capacity with less outside wall and roof area, and therefore less material cost. Strong and easy to

erect, the arched barn took its exterior covering from metal, wood, or asphalt materials. It became the last major change to barn silhouettes before the end of the farm building era.

Several other roof forms are seen less often, but left an interesting imprint in the West. The hipped-gable roof was often found on bank barns, particularly in southern Manitoba. Also called the clipped gable or jerkenhead design, this style is really a gable roof with blunted ends to the roofline. One advantage might have been an improved ability to deflect strong winds from directions other than the prevailing blows from the north and south.

No one did more to shape western barns than the guest experts who filled the pages of farm publications with tips, plans, and contests for better barns. Their almost holy quest was described by J.C. Colhart, who penned a comprehensive do and don't list under a series of articles entitled "Planning the Barn": "This rather simple title may seem a small matter to some," Colhart stated, "but with right-thinking

farmers it is the one ambition of their lives—good barns."

Practicality was the watchword of these free-advice dispensers. According to D.A. Hewitt, an eastern architect who often wrote for western agricultural newspapers, the first factor in shaping the barn is size and type of farm. He recommended a barn 70 feet by 50 feet for a two hundred-acre operation, a big barn for a big operation in those times.

Such experts didn't always agree. Nor did farmers then necessarily agree with "the experts" any more than they do today. For instance, Hewitt strongly advocated end-drive designs, which he said were superior to those entered from the sides, although many farmers seemed to agree with him that horse stalls should always be located closer to the house.

To give another example, Colhart said thatch roofs would become universal in Western Canada. A few years after this statement, thatch roofs were almost gone except in some of the poorest areas of the western farm community.

Nor were the experts afraid to point out farmers' greedy shortcomings when it came to farm design. "Because swine are blessed with keen appetites, strong digestion, and hardy constitutions capable of resisting a great amount of neglect and ill-usage, they have been, and in too many instances are yet, the worst-used animals kept for the profit of man," thundered the editor of a popular western newspaper then advocating better barns for pigs.

57. The most modern dairy barns of the era at Cummings farm near Winnipeg, Manitoba.

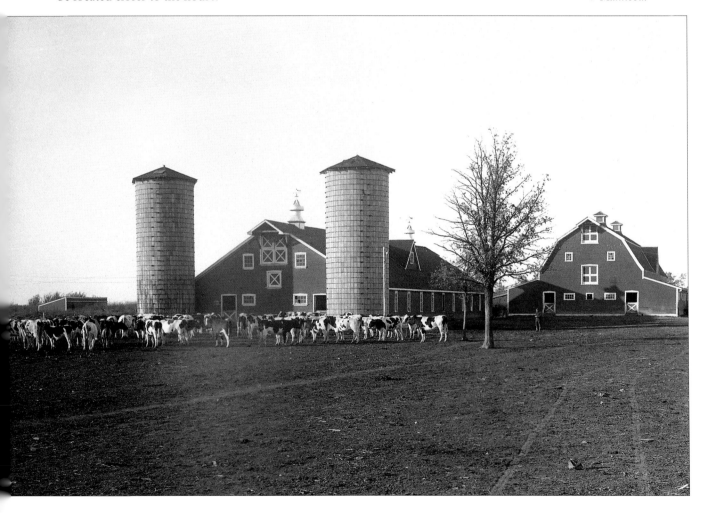

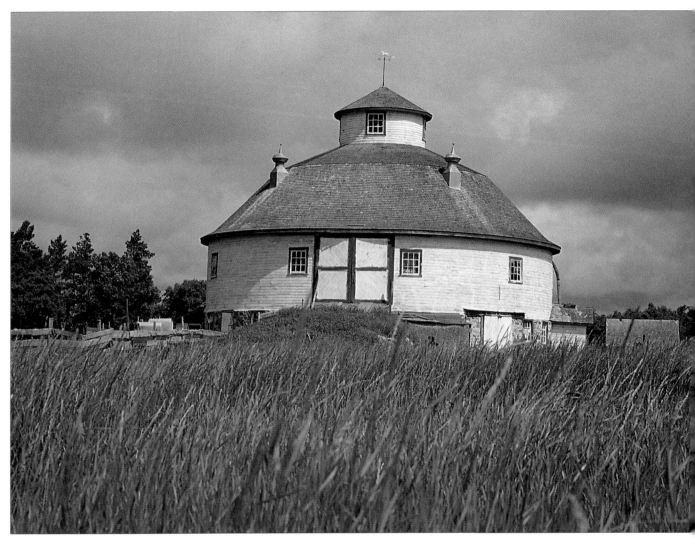

58. Earth ramps provide access to this large circular barn near Drake, Saskatchewan.

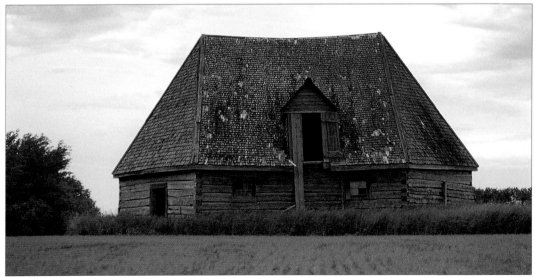

59. A six-sided log barn at Arborfield, Saskatchewan.

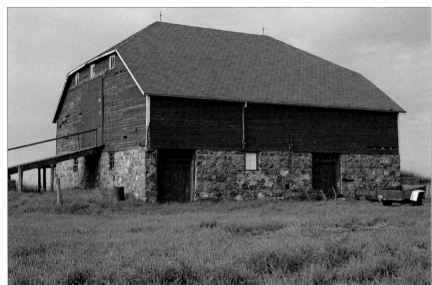

60. If hills weren't available for bank barns, then wooden ramps made the second level accessible to hay and seed wagons. Elgin, Manitoba.

61. The high moisture of the Rocky Mountain House region of Alberta has created lush growth, but causes early deterioration in farm buildings. This barn was built with vertical siding for easier rounding.

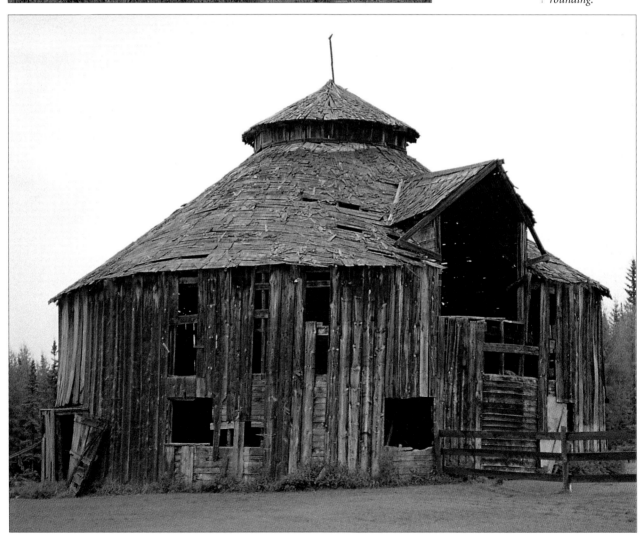

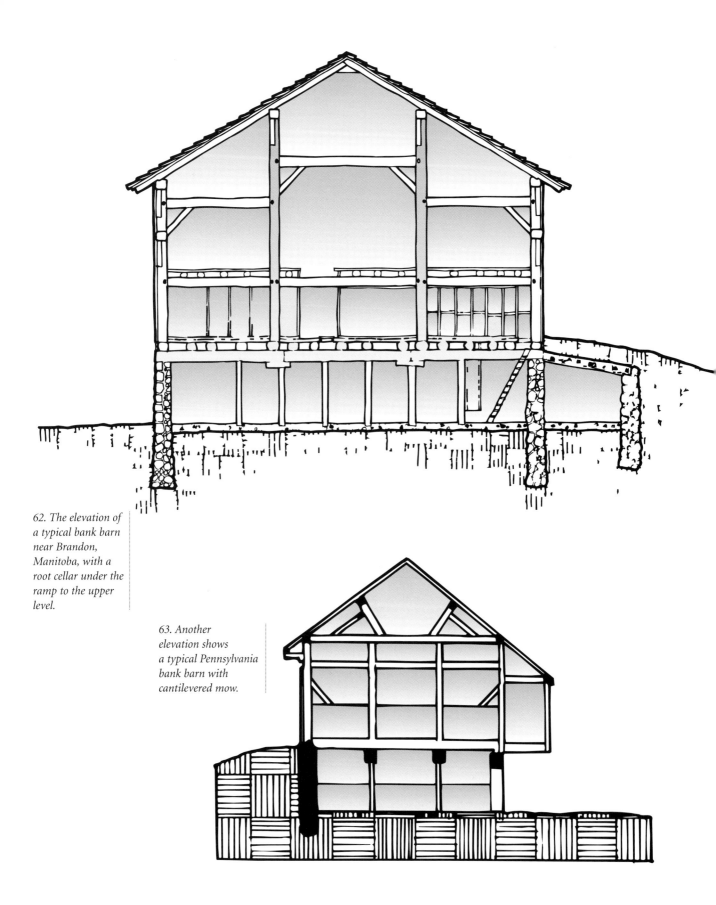

62. The elevation of a typical bank barn near Brandon, Manitoba, with a root cellar under the ramp to the upper level.

63. Another elevation shows a typical Pennsylvania bank barn with cantilevered mow.

Bank Barns

Pat Burns was a young Irish-Canadian lad who couldn't seem to wait for other people. He made this a credo for his ambitions: "The big thing to do is to do something and not stand still." Instead of waiting for delayed transport to new farmland areas in 1878, he walked the 130 miles from Winnipeg to what is now the Minnedosa area of Manitoba, and staked out a homestead.

But before long he was off to the foothills of the Rockies, and by 1900 he was operating Western Canada's most modern abattoir. Soon known as the Calgary Cattle King and one of the nation's Big Four cattlemen, Burns built many barns to assist his numerous cattle-related ventures. This bank barn (No. 64) was used to house horses for his Bow Valley Ranch along that same river, and is now preserved at Calgary's Heritage Park.

It is fitting to pick this example from the Burns empire because the bank barn is also regarded as the "king" of North American barn forms. Adaptable to different farm conditions, the bank barn usually hinted at a larger than average farm operation, as well as a relatively progressive owner. When one talks of bank barns one is often talking of buildings known as "Ontario" barns in Western Canada, "Pennsylvania" barns in the United States, or simply "basement" or "sidehill" barns.

Notched slightly into a convenient hill or sometimes butted against a man-made rise of earth and rock, the barns boasted major entrances for each floor level. Because of the cavernous capacity on each floor, these structures generally could be modified in line with the rapid changes forced on farm buildings after the turn of the century.

The bank barns of Western Canada do have a distinct family tree. Their closest relatives include the banked versions built in Ontario and the United States, some more than three hundred years old. The impressive barns of Pennsylvania, in particular, became favourite themes for companies or publications promoting better designs or pre-built packages to successful farmers.

The *American Agriculturist* was such a booster and frequently praised the merits of the Pennsylvania barn builders:

An ample barn for the storage of crops and the shelter of stock should be regarded as a necessary investment of capital in all farming in the Northern and Eastern States. This is better understood in Pennsylvania than in any other part of the country, and the barn that bears the name of the state, is, in many respects, a model.

Like most North American folk architecture, however, the genealogy of the bank barn form extends back more than three centuries. Most researchers point to Bavarian and Swiss models as the main influences on North American bank barn builders in the sixteenth and seventeenth centuries. Adapted from a more mountainous terrain, the style was not dissimilar to barn or house-barn forms of many European regions where the family occupied the upper level. Immigration from these countries directly to Western Canada had an obvious effect on the

64. Pat Burns built many barns for his cattle empire, this one along the banks of the Bow River, but now preserved at Heritage Park, Calgary, Alberta.

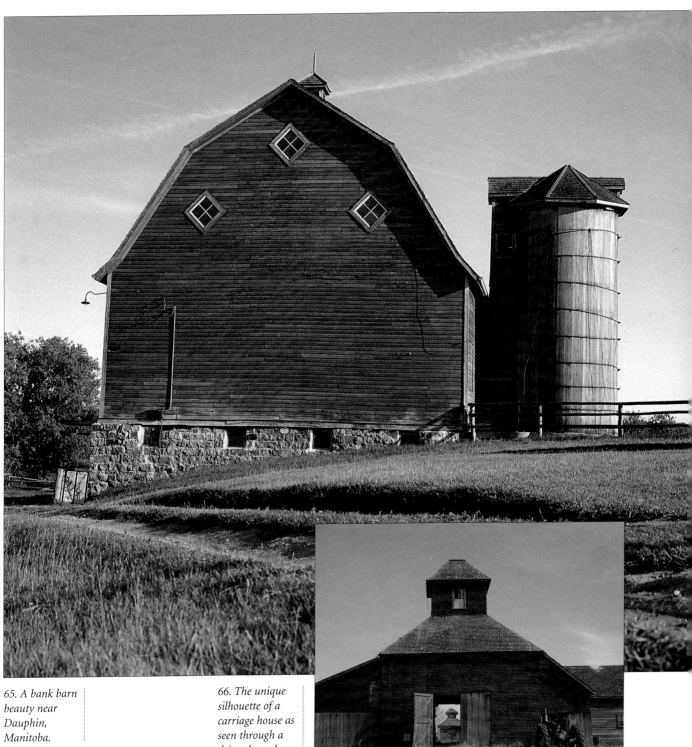

65. A bank barn
beauty near
Dauphin,
Manitoba.

66. The unique
silhouette of a
carriage house as
seen through a
drive-through
granary near
Carberry,
Manitoba.

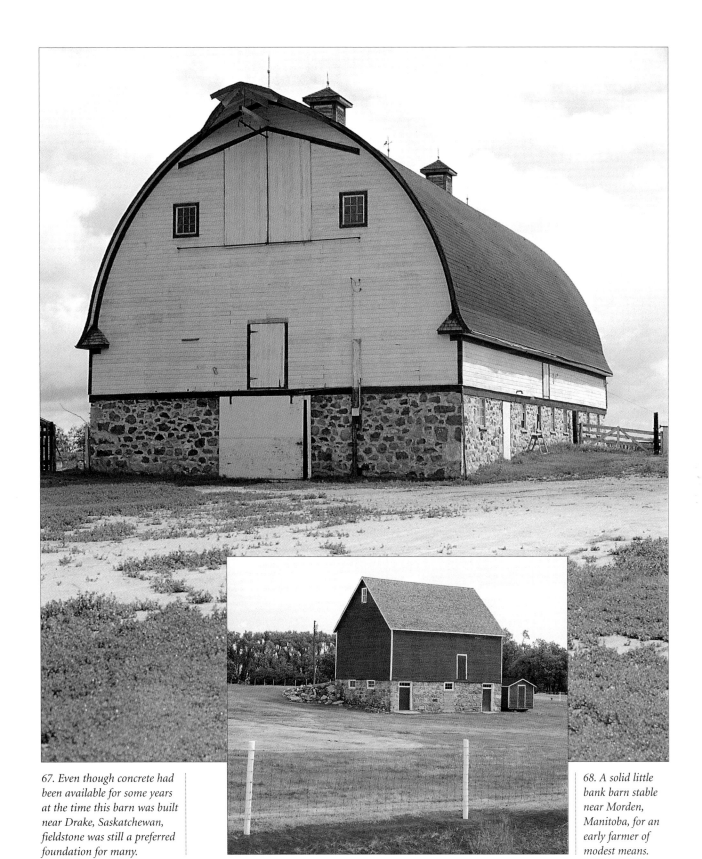

67. Even though concrete had been available for some years at the time this barn was built near Drake, Saskatchewan, fieldstone was still a preferred foundation for many.

68. A solid little bank barn stable near Morden, Manitoba, for an early farmer of modest means.

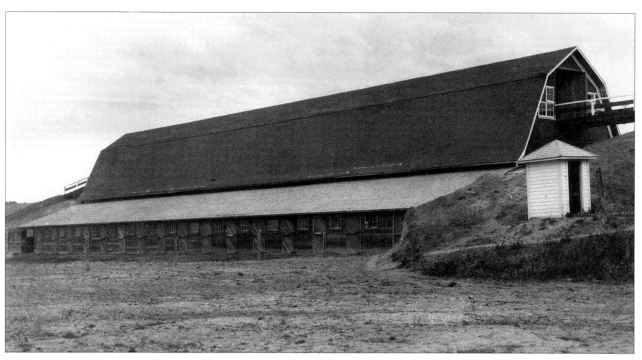

69. Hay wagons entered this barn from one hill, travelled the length of the loft, and exited on another hill.

acceptance and modifications of bank barns.

On the other hand, bank barns of North America had major differences from their European predecessors. They also had their share of critics until late in the nineteenth century when modern designs and materials were introduced to the barnyard.

In the original state, the end wall of a barn was most often notched into the hill; in Canada it was the longer side of the barn that was pushed into the slope. The latter allowed the main entrance to upper levels to be located in the centre of the side wall, which was a more convenient layout for turning large horse-drawn wagons. The invention of the haysling eliminated much of the need for wagon access to a second or third level of a barn.

Most North American owners preferred to site a barn with a lower level exposed to more gentle southern weather elements. Because the lower level always housed livestock, this also provided a natural windbreak for animals quartered outdoors during rainy or wintry storms.

In its original transfer to North America, the bank barn also featured a cantilevered extension of the upper floor forming a large overshoot or forebay. With the introduction of lighter framing materials this unique feature disappeared from the bank barn in the late 1800s, or just about the time of its introduction to Western Canada.

What was lost in exterior appearance by elimination of the overshoot was more than made up for by improvements in ventilation and sanitation to what critics called basement barns. Concrete replaced masonry walls and wooden or dirt floors. Improved ventilating systems brought fresh air to man and beast below. The problem of lower levels was outlined in early farm publications:

> The natural consequences of having masonry stable walls below grade was the ever-present condensation and mildew, which when combined with the vapours of decomposing urine in the ground and the formation of salt-petre on the stone walls, made for a generally unhealthy atmosphere for both livestock and for the crops stored on the floor above.

When one considers that bank barns also provided settlers with the only cool storage areas for vegetables or dairy foods, the concerns for sanitation was doubly urgent. Special cold rooms were often built into the lower level of a bank barn where the structure cut into the hill, providing a naturally insulated environment with a constant temperature.

The bank barn, perhaps more than any other style, encouraged a great many farm activities under one roof, and therefore was the first style to suffer from a re-ordering of the farmyard when steam threshers and tractors appeared on the horizon. Granaries, milk houses, and silos became separate and increasingly large structures. Still, the bank barn with its enormous floor volumes proved it could adapt and continued to be used well into the 1900s.

70. A double-door bank barn with an upper entry also features a distinctive gable-on-hip roofline near Manitou, Manitoba.

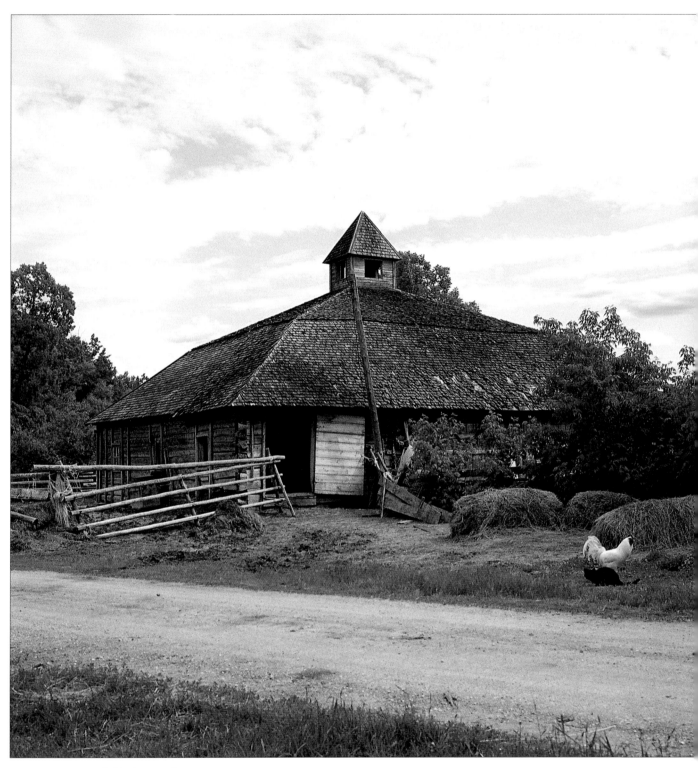

*71. A square barn near
Lac du Bonnet, Manitoba,
built using local log and
store-bought shingles.*

Materials of Progress

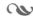

If western settlers seemed to share a common characteristic during the earliest settlement periods, it was a desire to be independent. For a time, most farm units were generally self-contained, with materials for shelter and food readily available from their own land. Early barns reflected this spirit of "making do." The land was initially rich in building materials: timbers for the massive beams of larger barn designs being introduced to the West; stones and other earthen materials for masonry work; and sod and thatch for the start-up years. When combined with the offer of free land, many a farmer was able to live his dream many years ahead of what normally would have been the case without "making do" materials.

> *The primitive barn combines all that is quintessentially rustic: crudely notched and rough-hewn logs, hand-wrought hardware (if indeed there was any), and of course hinges, all assembled in the simplest manner. Its character has long been perceived as hardy, spare and virtuous in its unity and its rugged surroundings. The log barn possesses such enviable qualities that many 19th century politicians claimed a special blessing for having been born in at least its domestic equivalent.*
>
> RICHARD RAWSON, *OLD BARN PLANS*

But even by the turn of the century continued self-reliance or independence was largely illusory. New forms of farm power were beginning to challenge traditional farm methods and the economics of self-sufficiency. Quickly depleted prairie forest resources meant adoption of new building techniques and materials. It also meant ever-increasing trips to town for the factory-made materials that were being offered for construction, and the protection and modernization of older barns.

As railways pushed into all corners of every province, along came the opportunity to export surplus farm produce for cash, which in turn was used to improve or expand the farm. As the trains brought mail filled with catalogues and agricultural bulletins urging new designs and

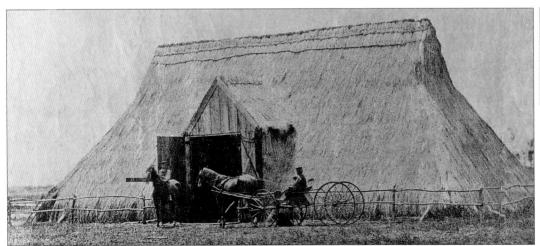

72. There is strong influence of European building traditions in this 1875 all-thatch barn in southern Manitoba.

factory systems for barns, individualism began to disappear from the farmyard. Bright, light, and economical, the newer barns were a product made thousands of miles away, and most often erected on site with hired help. The traditional barn was able to adapt to new technologies for only a while.

Today's barns are more often "machine sheds," scorned by romantics and unrecognized by traditionalists—but every bit as necessary in shape and material as were the older barns in their time.

Log, Sod, and Thatch

A.R.B. of Ste. Agathe, Manitoba, was one of the more accomplished letter-writers who appeared regularly in early western farm journals. He attacked his subject with feeling and depth of knowledge. Like other letter-writers, he used the forum as a prime method of exchanging new ideas, or challenging old concepts.

Perhaps well-known in his era, his letters were followed only by initials and his identity, therefore, remains a mystery. His views on thatched roofs for barns were particularly strong, and, while they might appear backward today, represented majority thinking in that period of hot debate over the benefits and perils of thatch.

One of A.R.B.'s letters in 1893 challenged the shift in thinking that was taking place:

In the winter of 1879, I examined buildings in the Rat River Mennonite Reserve constructed altogether of thatch. Even the barn doors were of thatch, on a framework of poles; and the roofs of those buildings are today, apparently, as sound as when I saw them over fourteen years ago. They were of course swamp grass, tied on with twisted ropes of the same material. These people tell us that rye straw, properly put on, will last twenty years. I have known of roofs on the houses of half-breeds, along the Red River, whose owners gave the time of their con-

struction as over thirty years ago, and with the thatch still turning the rain. These latter were put on with mud.

A.R.B. compared styles and materials:

The mud style of putting it on may be disposed of as entirely unsuited for any but small, log buildings; and the Mennonite plan of putting it on with twisted ropes of hay is too slow, and not even economical, from the time taken to do it.

Rye straw was the best material, he maintained, although certain kinds of swale grass made durable thatch. Make the thatch roof steeper than ordinary, or about 45 degrees, advised the letter-writer, and use tamarack for the framework, if possible. The frame would require stronger support than a wooden roof because of greater weight carried in rainy weather:

The element of cheapness is a consideration of great account in times like the present, and it would appear that in this country at any rate, through the operation of tariff laws, freight rates, combines and so on, a dollar comes far short of buying a dollar's worth of almost any kind of building material, and it would appear to be the duty of every farmer to refuse to buy or trade in every case where he does not appear to get a fair deal, and thus become independent of those who are at present time responsible for his difficulties.

The plea of poverty and the high prices of lumber condones the leaving exposed to the weather all kinds of valuable farm implements, and a remonstrance is generally met with the statement that it costs more to house machines than to keep up the wear and tear caused by them standing outside, I propose to show that the plea is without justification.

73. A 40-foot-square log barn with layered sod roof built near Redvers, Saskatchewan.

74. An elderly Ukrainian woman, who preferred a solitary lifestyle in southeastern Manitoba bush-land, built and thatched this stable in the early 1980s.

75. There were sodding bees, as well as barn raising bees. This one took place around Tullisville, Saskatchewan, in 1908.

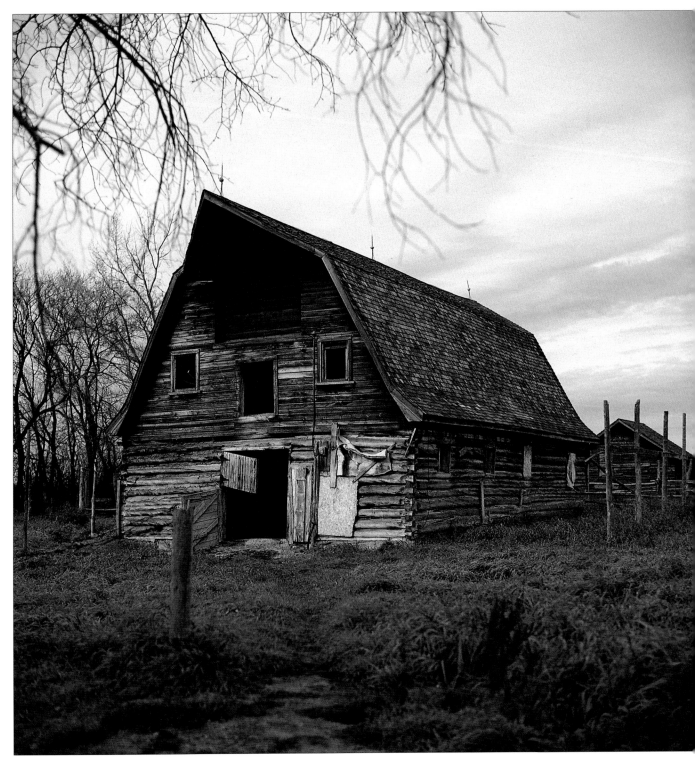

76. A modern adaptation of an ageless material built at Dauphin, Manitoba, in the early 1920s by a returning war veteran.

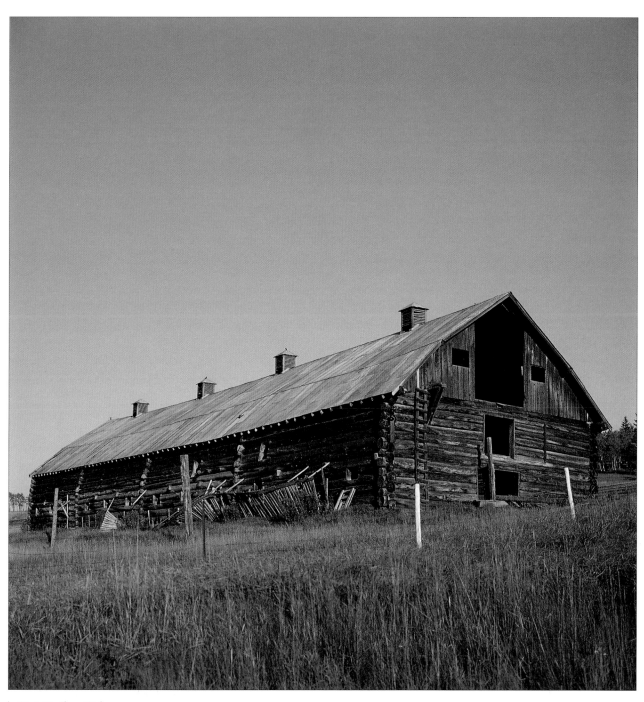

*77. A Cariboo Highway
barn with long log sides
near 108-Mile, British
Columbia.*

A.R.B. won neither the battle nor the war. Thatch roofs were a material of absolute last resort despite the economies, and soon disappeared from the western landscape.

Sod was another material promoted by early agricultural editors. The *Nor'West Farmer and Miller* was still promoting the idea to a rapidly growing readership in 1890:

> Roomy barns, 30'x 40' inside, with sod walls and roofs, are seen everywhere—two or more perhaps on one farm. If the turf is at all strong, a wall of this sort will last half a century provided it gets justice, and is more snug inside than most of our wooden erections, though after a prolonged drought the roof sods are barely up to the mark as a defence against a heavy rain.

The farm newspaper went on to caution those of limited finances to use nature's resources and not get over-extended too quickly at the bank:

> The country is not fully settled yet, and when a man of limited means has to decide between half a dozen good cows and a wooden house that will only imperfectly defend him from an ordinary cold wind, I want him to look out for a good mud hole, cut off the thick grassy sods to be used in building the first foot or so of the walls, and after that go on with the cob building, while the cows are providing for themselves and their owner, rather than to go into debt for boards and take chances on paying for them out of his first wheat crop.

Sod structures did not survive prosperity. In addition to increased fire hazard and diminishing structural strength with advanced aging, the biggest problem of soddies was their image of being a last resort. In some parts of Western Canada, sod was used as late as the 1940s, but usually only in cases of absolute necessity.

Although the log barn was seen on farms in every region of Western Canada, the greatest frequency still is to be found in the parkland fringes of Manitoba, Saskatchewan, and Alberta, perhaps a proper reflection of the setting back in the late 1800s. In many cases, the

78. A primitive straw barn constructed of young poplar trees rafted together with straw thrown on the top and sides.

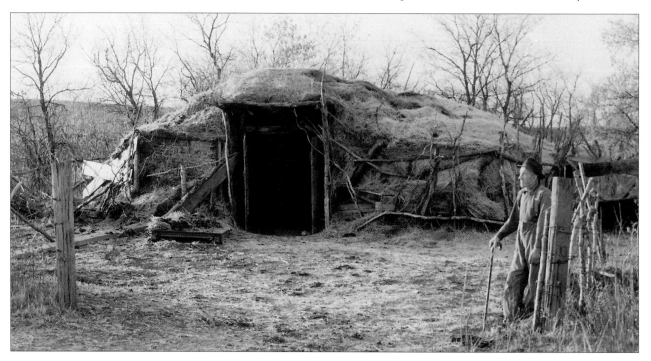

interiors have been plastered or boarded over for the past seventy or eighty years, usually after the structure was converted to a granary. In other cases, a log exterior was often covered over when it became a wing of a newer, larger barn that frequently was built within ten or twenty years of initial homesteading.

Preferred methods of log construction across the four western provinces included saddle-notch or dovetail construction. The former method was speedy and most flexible for settlers, although it was also frequently associated with logs that were not tight fitting and required a form of chinking. Compared to dovetail techniques, the saddle-notch method usually allowed easy expansion at a future date, although in both cases the size of the structure was restricted by the size of logs available.

Where chinking was required, early settlers utilized several different materials, but straw or daub seems to have been the most popular. The daub was an unlikely mixture of clay and straw (sometimes with lime or manure added) that often required someone in the family to knead it with bare feet for many hours.

80. An unusual vertical log barn
with board and batten roofing.

59

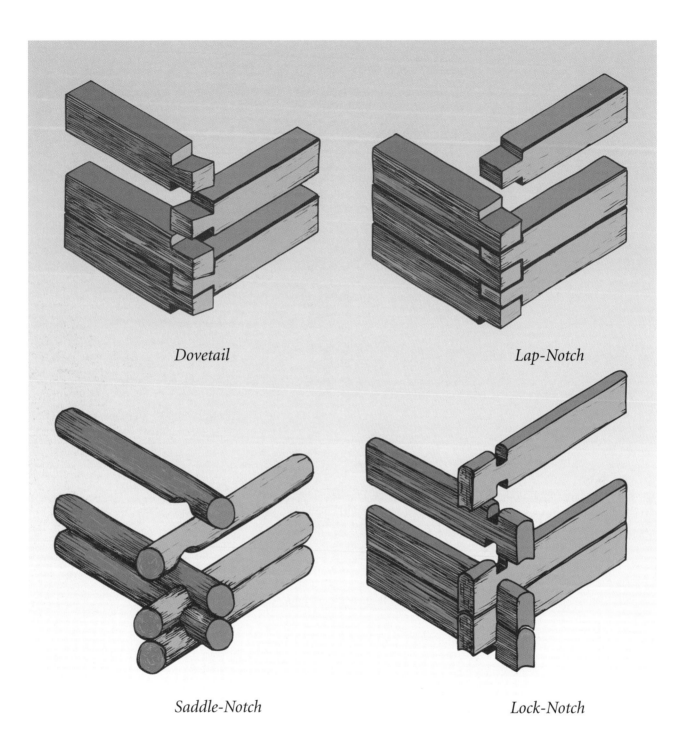

Dovetail

Lap-Notch

Saddle-Notch

Lock-Notch

81. Methods of log construction

82. Dovetail corners for the house and saddle-notch corners for the barn are evident in these buildings near Douglas Lake, British Columbia.

Earth and Stone

Blood Indian entrepreneurs on the Pothole Coulee Ranch near Lethbridge in 1888 produced a barn (No. 83) unique to Western Canada. It was an example of how earthen materials were used by early farmers to create shelter for themselves and their livestock.

Digging deep pits into the soft terrain, and filling the bottom with coal from nearby mines, the Natives then heaped piles of fossilized shellfish onto the burning coal. The coal was allowed to burn for several days, during which time the shellfish were transformed to a kind of cement. The powdered cement was mixed with gravel and sand to provide a form of concrete popular in foundation work. Although no one understood why the shellfish converted to cement, they knew they had enormous supplies to work from.

In the case of the Pothole Coulee Ranch barn, entire farm buildings were constructed by the entrepreneurs, who also operated their own mines in the late 1800s. Government agencies are said to have discouraged the Blood Indian miners, and the building form did not receive much notice outside the immediate area. Several examples of this type of construction material still stand in the region.

The earth gave up varied forms of building materials for early farmers, or in later years to companies interested in manufacturing finished products for farmyards. The fieldstone buildings of the flatlands, or sandstone barns in Alberta were such examples, as were the early mud-straw bricks made by immigrant farmers in Manitoba and Saskatchewan, or the mud-lime-straw-manure chinking used to seal log buildings.

Bricks fired from the unique clays of Western Canada were as good as any in the British Empire, and costs ran as high as $12 per thousand from the many brickyards that followed up behind railway expansion. As well, there were numerous examples of new products offered to

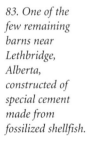

83. One of the few remaining barns near Lethbridge, Alberta, constructed of special cement made from fossilized shellfish.

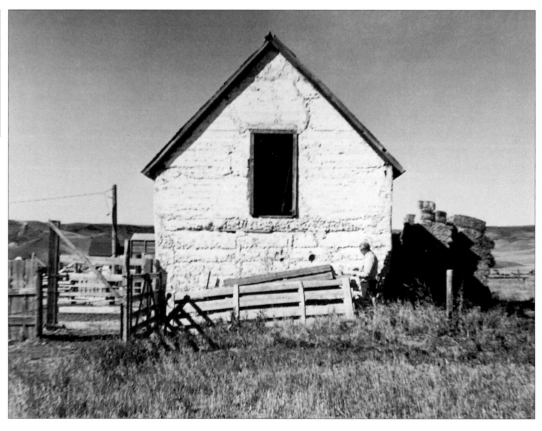

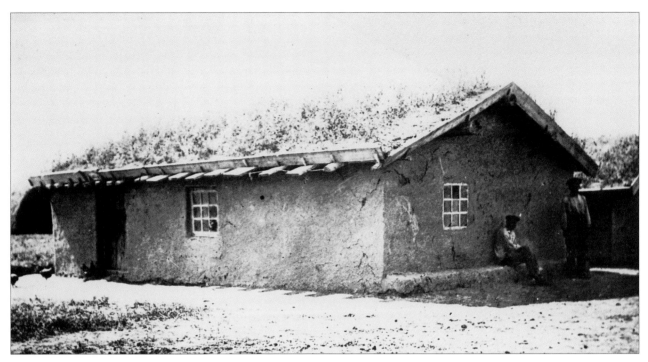

farmers to replace the heavy and time-consuming task of laying fieldstone foundations.

Sir Walter Clifford was a progressive farmer who led others by example. By the turn of the century he had been among the first to breed and show the popular new Aberdeen Angus line, going on to become the first president of the breed's fledgling Canadian association. Running a farm operation of considerable proportions, Sir Walter was not unaware of the smaller innovations and ideas raining down upon western farmers at the time. Items introduced to the region by the Austin-area farm leader included things such as cream separators and building blocks for barns.

A contradiction to the theory of size of barn reflecting size of operations might be Sir Walter's concrete block barn (No. 87). A tiny 16 feet by 32 feet, the two-storey barn was one of several on the farm, but had to be one of the smallest built of masonry materials in the province. However, it represents progressive thinking on the matter of new building materials.

Do-it-yourself block moulds had been promoted in farm papers for some time, and were

part of the larger switch in barn building away from the huge fieldstone foundations to less expensive materials such as cement or brick. While fieldstone was still available in reasonable quantity in many parts of the province, expert stone masons were not as plentiful. Nor could farmers always compete with wages offered craftsmen for construction or repair of houses in towns and cities.

The use of building blocks for farm structures never really caught on except in a few areas

84. A typical sod roof of Doukhobor farmers with plastered log construction.

85. Mud and pole barn construction from the Dirty Thirties at Tilston, Manitoba.

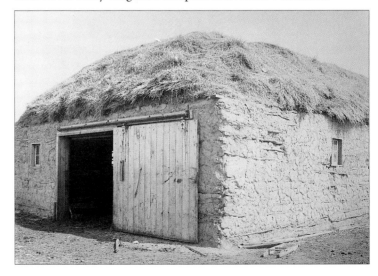

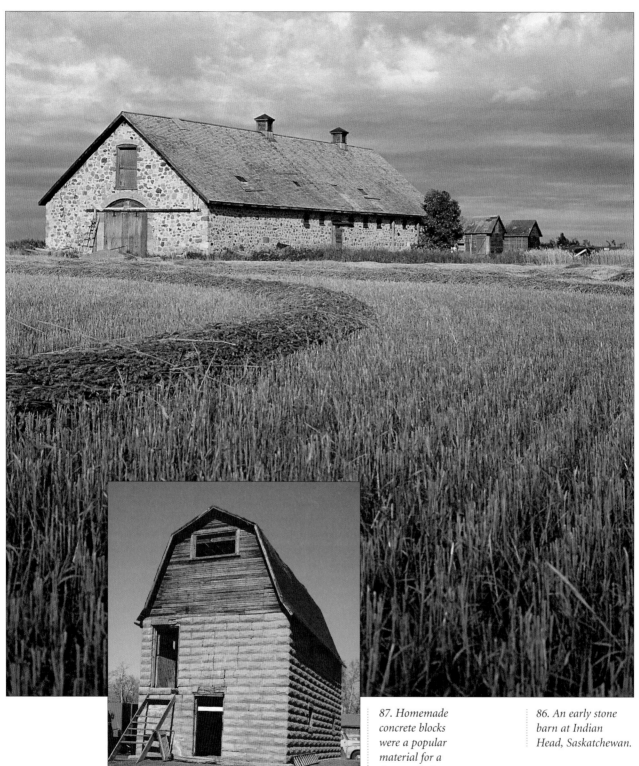

87. Homemade concrete blocks were a popular material for a short period, as used in this barn near Austin, Manitoba.

86. An early stone barn at Indian Head, Saskatchewan.

*88. This building
near Edgeley,
Saskatchewan,
reveals a taste for
British stable
design.*

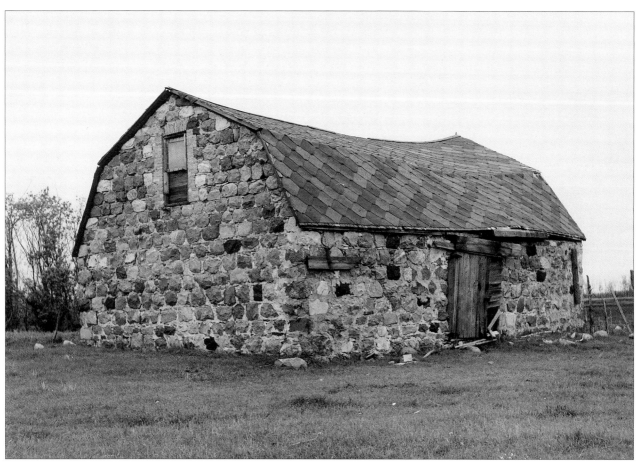

89. A patterned spirit bowed but not broken near Elkhorn, Manitoba.

of southern Manitoba and Saskatchewan. Surprisingly, most examples have survived relatively well compared to types of masonry walls under barns of the same age. The blocks were most often made right on the farm by pouring a cement mixture into the moulds. The moulds were either resold after use, or returned to rental firms.

Like sod and thatch, the mud brick or cob-walled farm buildings generally were regarded as unsuitable once a farm had passed the formative stages. Milled lumber set upon fieldstone or cement foundation walls projected the "right" image.

Perhaps the biggest debate over barn materials centred on the choice of cement versus fieldstone. The debate continued well into this century even though cement was fast converting the convenience-minded. The first concrete farm building did not appear in Britain until 1870,

and the resulting controversy was almost as emotional as when pro-mechanization forces later railed against the pro-horse set. In both cases, the meeting place was the Letters to the Editor columns, and some big names regularly took up the various causes.

S.A. Bedford was head of the federal experimental station at Brandon and considered one of the progressive thinkers in agriculture. Still, he favoured fieldstone, and wrote in 1899 that stone basements were still the best. He recommended footings at least 30 inches thick and walls at least 24 inches thick.

He also warned farmers against the most common problem of fieldstone foundations: don't run out of stones. It seems the low headroom exhibited in some early bank barns stemmed not from the stature of settlers or their stone masons, but rather from "short" pencils used in estimating the required volume of stone.

90. Fieldstone was a principal building material in several areas of Manitoba and Saskatchewan. This barn near Carlyle, Saskatchewan, illustrates the unusual style of continuing fieldstone up to the gable peaks.

91. A famous Cannington Manor area operation, the Becton Ranch for prize-winning livestock.

92. Mud and straw were combined to make bricks, which in turn made stables such as this one at Glidden, Saskatchewan.

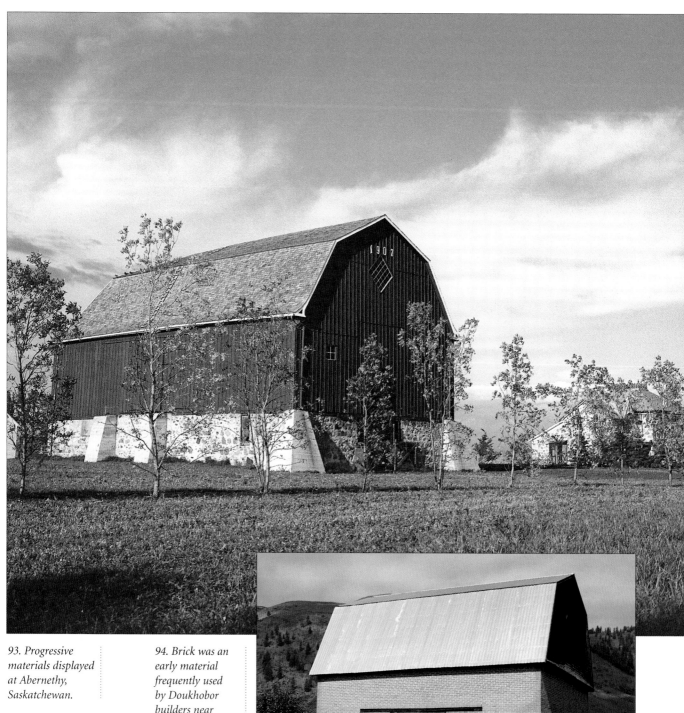

93. Progressive
materials displayed
at Abernethy,
Saskatchewan.

94. Brick was an
early material
frequently used
by Doukhobor
builders near
Grand Forks,
British Columbia.

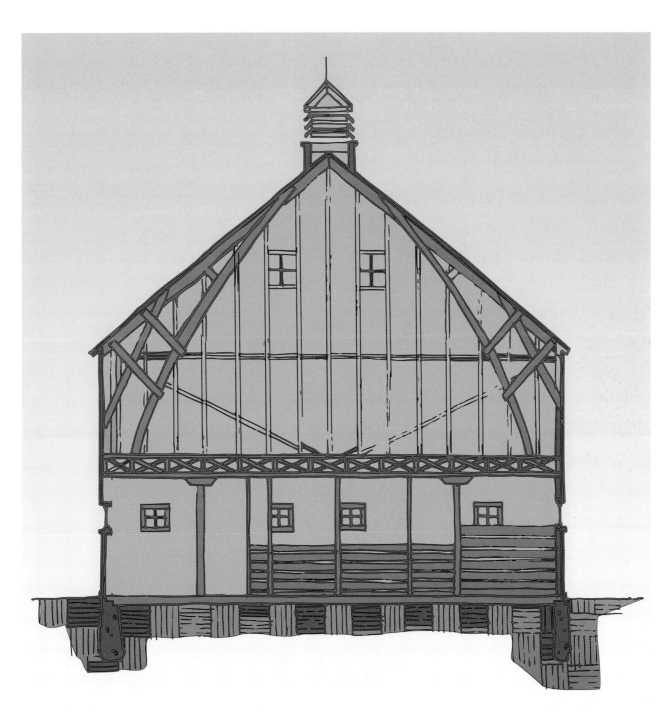

95. New-style truss framing for a gambrel roof near Brandon, Manitoba.

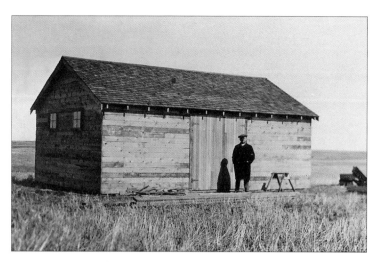

96. Ready-made barns did not mean ready-made settlers. These were the standard barns erected for Jewish settlers at the Sonnefeld Colony near Oungre, Saskatchewan, in the 1920s. Very few stayed farming.

One building material sometimes found in surprising locations was brick. While usually restricted to areas with nearby brickyards, it was a material some builders would travel a long distance to secure.

Jack Howden was a Scottish lad who came to the Edgeley area of Saskatchewan in 1890. He wanted brick for his excellent new horse stable to be erected about 1912. Showing distinctive design elements from larger-scale barns of his homeland, the Howden barn (No. 88) is the only brick barn within the region, and small wonder. The many loads had to be bounced over seventy miles of wagon road, making one wonder how a sufficient number of bricks survived the trip to complete the structure. And yet, the Howden stable would simply not look nearly as "right" in any other material.

Man-Made Convenience

W.R. Motherwell was a leader on the great western plains—in the political trenches where he helped win important policies for farmers as a provincial, and later a federal minister of agriculture, and on the farm where he declared his buildings and methods to be demonstrations of the most progressive attitudes. One would be hard pressed to find a more typical success story of early settlements in the West, perhaps the reason why his farm was declared a national historic park in 1966, and restored for public appreciation.

Motherwell came to the Abernethy area of Saskatchewan in 1882, fresh from the Ontario Agricultural College and full of ideas on the proper way to farm. He would later be seen as the leading edge of the wave of eastern farmers who would sweep across the virgin prairie soils, leaving behind an indelible imprint of early Ontario social and political structures, as well as influencing the design of many farm buildings.

Typically, Motherwell's first buildings were of prairie sod and log. After experiencing crop failure and other setbacks, he began to expand on his modest beginnings. By 1889, Motherwell had broken one hundred acres, and soon acquired a neighbour's quarter-section. In 1896, after many years of patiently collecting field-stone from the coulees in the area, Motherwell hired a stone mason to construct a better barn (No. 93) and house. It is noteworthy that he did not allow the mason to begin the house until the barn work had been completed.

As farm size expanded and new materials became available, the character of the Motherwell barn also changed. For the first ten years, the limestone foundation supported a stable roofed with logs and straw. It wasn't until 1907 that the L-shaped frame barn was completed, the basement divided into distinct areas for horses, cattle, and pigs, and an upper level completed for grain and hay storage.

The double pitched gambrel roof, the vertical siding, earth ramps, and concrete corner buttresses became indicators of progress in the barn's development, something that continued right until the structure ceased to play a central role in the farm operations.

Government policies promoted by Motherwell brought expansion of farms in Western Canada. This in turn encouraged a packaging of plans and materials for farmers that, along with mechanization of farm equipment, was the final step in making the agricultural community both beneficiaries and dependents of faraway city factories.

Whether this was good or bad is a matter that will be debated for decades to come, but it made

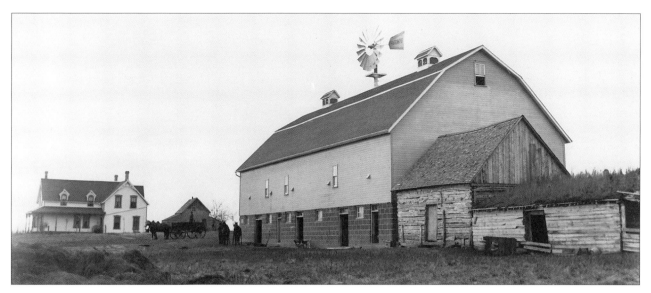

the barn an efficient and tolerable workplace, and extended the barn era by several decades. Better glass, better paints and coverings, hayslings, asphalt and rubberized roofing, metal siding and roofing, laminated rafters, and well-engineered lightweight roof trusses were only a handful of the offerings to barn builders. Concrete, building blocks, and brick were also introduced to barn building about this time.

Farm publications now had large readerships and began to promote efficiency in design and cost. What had until then been passed on from generation to generation by word of mouth was now offered in crisp, black typeface. Publications were filled with how-to-build articles, as well as ads and paid articles on new materials and methods.

And even though the farmers of the time were said to have had very poor reading abilities, and even though many immigrants had only the slightest grasp of basic English, it was difficult for them to escape the efforts of governments, industry, advertisers, and editors.

Farm newspapers and magazines initially came from Eastern Canada and from the United States. When the first Western Canadian editions appeared late in the 1800s, the attitude towards new technology or ideas was improved dramatically. The *American Agriculturist, Canadian Agriculturist, The Farmer's Advocate, The Nor'West Farmer, The Canada Farmer,* and *Free Press Weekly* were examples of prominent trade papers.

At the same time, companies promoting use

97. The Hugh McPherson barn progression at Brandon, Manitoba, speaks of economic and commodity periods—from crude log and sod, to trimmed log and milled lumber, and finally, a frame and concrete giant.

98. Even canvas was an acceptable temporary barn material in the early 1900s near Gladstone, Manitoba.

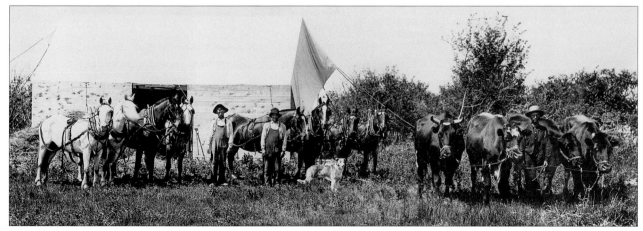

99. Barn No. 7 in a series of Canadian Pacific Railway ready-made buildings, sold to a home-steader for $1,050.

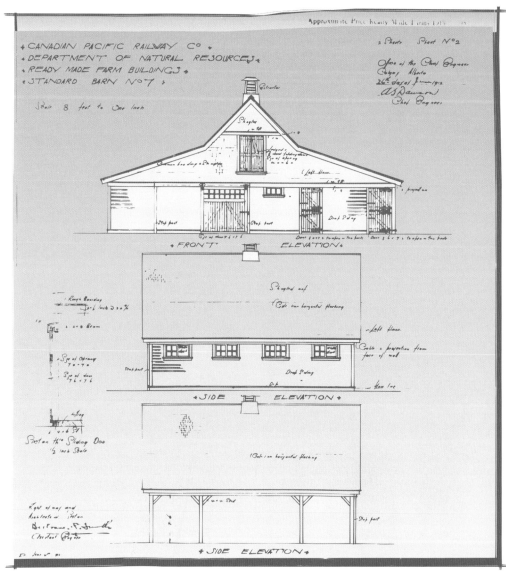

100. One of the featured barns in the Beatty barn plan books, this one a large U-shaped dairy barn belonging to Percy Lasby Farms near Moose Jaw, Saskatchewan.

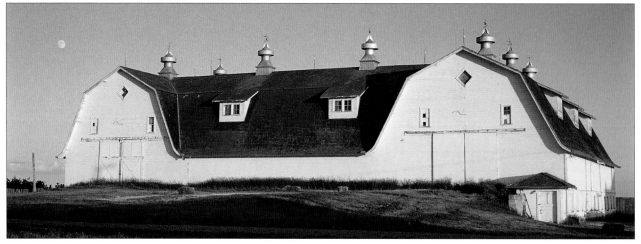

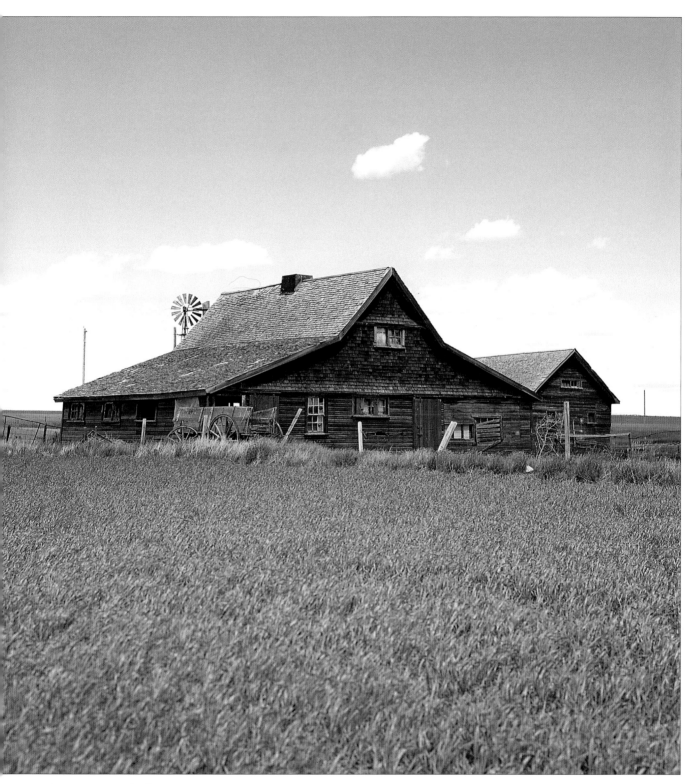

*101. An example of
plan No. 7 located at
Vulcan, Alberta.*

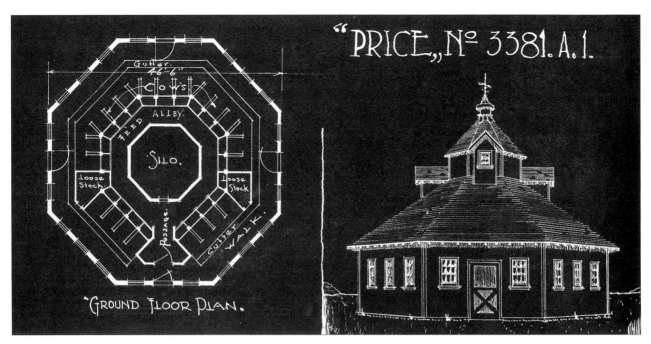

"PRICE" Nº 3381. A.1.

GROUND FLOOR PLAN.

102. Crown Lumber was one of many companies to offer ready-made farm building packages from catalogues, including this octagonal pattern No. 3381.

of their equipment or materials soon began publishing "professional" plan advice. *Louden Barn Plans* was put out by the Louden Machinery Company about 1917, while the *Beatty Barn Books* were published later by Beatty Bros. to help promote pumps and dairy interior systems. The Radford Architectural Co. produced a popular book, *Radford's Practical Barn Plans*, about 1909. Lumber companies and chain stores like Sovereign, Crown, Eaton's, and Sears contributed to the introduction of the modern barn era with special catalogues on material packages for the widest range of farm buildings. These included houses, barns, granaries, piggeries, chicken barns, and implement sheds for the new equipment then making a substantial appearance in western fields.

For example, in its 1917–18 special catalogue of building supplies, Eaton's gave an enormous selection of packaged houses, barns, sheds, school houses, and just about any other building form required. Their barn package highlight that year was the reproduction of a barn that had won first prize in the Winnipeg 1914 Exhibition. Farmers could buy the plan for $1, or they could buy the package, a 36-foot-by-76-foot barn for $1,477.

Added momentum to acceptance of package barns came from one of the largest economic interests in the West at the time—the Canadian Pacific Railway Company. Not only was the railway interested in selling its land grants back to farmers in order to create increased freight traffic to and from Eastern Canada, but it frequently sweetened the land deal with its own set of house and barn plans and ready-to-farm packages.

The railway offered a rebate of 50 cents an acre for each acre cleared, and also altered its colonization policies several times to encourage cultivation. Between 1888 and the end of the century, it provided an average loan of $300 per settler for houses and implements, and later offered land on twenty-year leases and loans of up to $2,000 to build barns, houses, or wells. After 1910, the company provided ready-made farms, complete with house, barn, toilet, pump and well, fenced, and fifty and one hundred broken acres. Only married men and families could get the twenty-year deals. Many of these CPR barns (No. 101) can still be seen today in parts of Alberta.

BARN. No. 7.

103 & 104. Additional examples of ready-made Canadian Pacific Railway farm buildings.

HOUSE No. 4.
BARN No. 1.

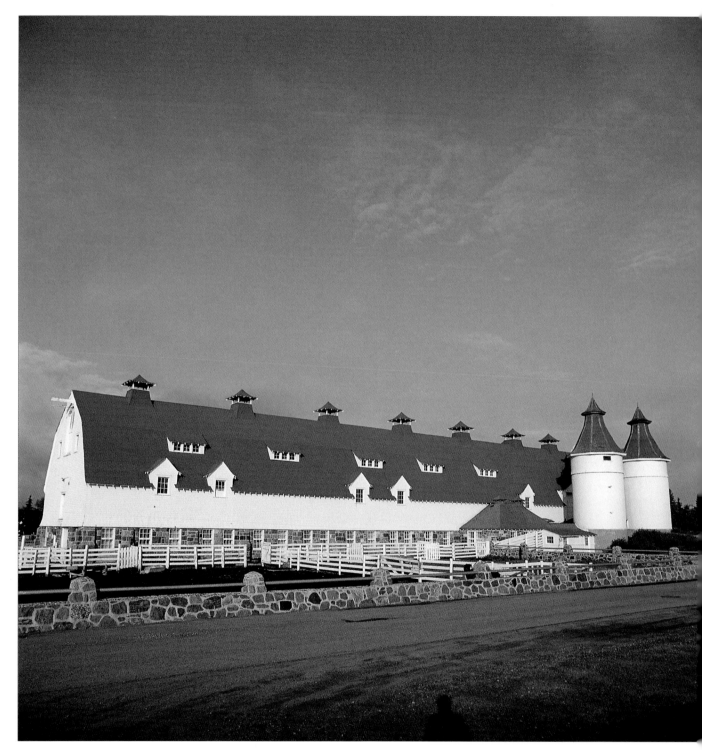

*105. The impressive
University of Saskatchewan
barn in Saskatoon.*

Mirrors of Diversity

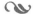

Once upon a time everyone needed a barn. Farmers. City businessmen. Police and fire departments. Churches, schools, and hospitals. U-drive stables. Fairgrounds or universities. If one had horses or livestock, one had a barn. If someone catered to travellers, one required a weather-tight and warm barn. Other than the family shelter, there was no other type of shelter more important to the dreams and ambitions of westerners.

Were individuals judged by their building? It is often suggested that such was the case, that financial circumstances or community status was expressed by the size and condition of a barn, for example. Was the owner dull and unimaginative, lazy or slow with repairs, or perhaps creative in the design and materials used? What importance did a farmer place on working buildings relative to the house? Did an owner imitate the successful designs of others, or take pride in his own architectural spirit?

The following pages touch only a handful of stories about barns and their uses. They include unique towers of fox farms, educational and research barns, and other rare architecturally designed barns. The barracks-like stables of the North West Mounted Police, who kept the peace around new settlements. The barns of Doukhobors who came west to find religious freedom. The log structures of the Cariboo Highway, once a desperate trail for restless men searching for gold. Then there were the more elaborate buildings of showmen seeking recognition in show rings of Europe and North

> *A simple and certain test for determining who dominated a pioneer family: A man's domination was demonstrated by the existence of a big barn and a shack-sized house.*
>
> ATTRIBUTED TO NELLIE McCLUNG, FAMOUS CANADIAN SUFFRAGETTE, NOVELIST, AND DIPLOMAT

America. And the barns of the railways, either marshalling livestock for export or helping feed huge track-building crews and passengers riding the new transcontinental services.

The barns of the West have even served the needs of Hollywood, including portraying the simple farmyard where Superman grew up as a just plain Clark Kent of Smallville.

Earlier this century everyone needed a barn. Today few people need or want barns and fewer still can accept the cost of maintaining irreplaceable links to a relatively young heritage.

Special Barns

The only thing remaining of Horseshoe Smith's grand ambition is a 400-foot by 128-foot foundation of broken concrete, located near Leader, Saskatchewan. It marks the site of what once was North America's largest barn (No. 109) and

106. A fortified barn was a rare sight on the prairies, although these stables at Stony Mountain Penitentiary near Winnipeg in the 1880s featured gun towers at each corner.

77

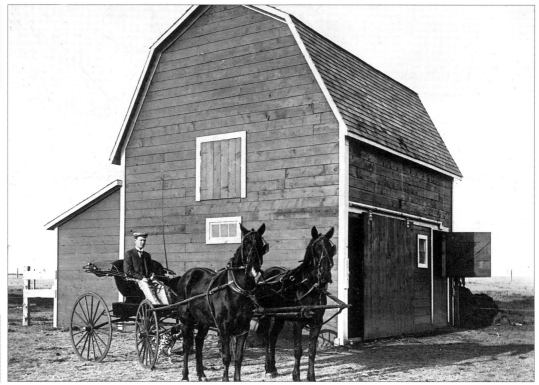

107. A typical stable for a country doctor, in this case Dr. Sawdon of Three Hills, Alberta.

108. The North West Mounted Police riding school at Regina, Saskatchewan.

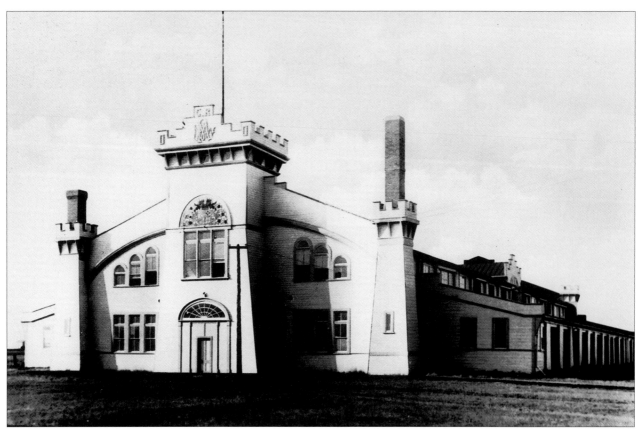

the remains of a dream not so different from those of many other settlers—someday to be the biggest or the best in the world.

W.T. (Horseshoe) Smith came closer to completing his dream than did almost anyone else. In the end his failure allowed some of his neighbours' dreams to be realized. In 1923, less than ten years after it was built, the huge barn was ordered dismantled by a finance company and the lumber sold to area farmers who, in turn, built more modest stables, barns, or homes. It was a pattern that would repeat itself many

branched into all phases of ranching. At one time more than 160 men tended some 2,000 horses, 1,600 mules, 2,000 hogs, and 6,000 sheep.

Smith's own sawmill provided the materials for other farms in the region, including his first barn, a modest 100-foot-by-30-foot structure featuring solid walls of two-by-fours laid one on the other. It burned down in 1911, creating the need for a new barn for the 10,000-acre operation.

A small British Columbia forest must have been freighted to the Saskatchewan prairie by

109. North America's largest barn at the time, located near Leader, Saskatchewan, was later dismantled to provide lumber for many smaller barns.

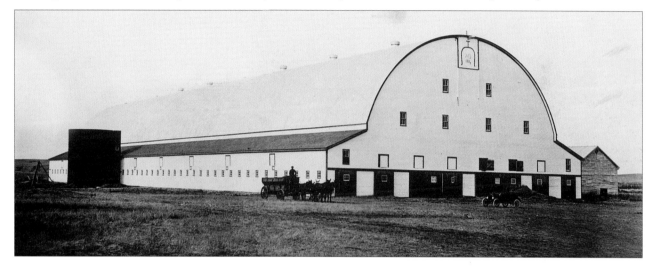

thousands of times during the settlement of Western Canada—gigantic ambitions, but small to medium-sized successes.

Was the Smith barn a symbol of failure or the epitome of what drive and ambition could achieve in the new agricultural frontier? Certainly there was not another like it. It became both monument and memorial. "That barn killed me," Smith confided to one of his men as he approached death in 1918, "I wish I'd never built it. It just broke me completely."

In 1901, Smith had moved west from Winnipeg, where he had operated a large feed and butcher business. A native of Kentucky, he found lush grassland and good water near the junction of the Red Deer and South Saskatchewan Rivers. Borrowing heavily from a Winnipeg relative, he established a horse-breaking operation that grew quickly and soon

the time this building was finished. More than thirty-two carloads of lumber were required, along with 30,000 sacks of cement, 60,000 feet of galvanized roofing and a carload and a half of nails to keep 100 carpenters busy.

The traditional opening barn dance was an extravagant affair, but the draughty, damp barn proved a tremendous disappointment. Many of the 1,200 cattle housed there died during the first winter, a setback from which the ranch never really recovered.

Smith acquired his nickname "Horseshoe" from his branding iron mark, an inverted horseshoe. It seems no one told the man of great ambition and surprisingly quiet nature that good luck falls out of horseshoes that are not held points up.

Whereas the Smith barn is a special barn that no longer exists, the magnificent University of

110. Located near
Stonewall
Manitoba, this
barn is a symbol of
a fur-farming in-
dustry that has all
but vanished.

111. A fox tower
at Steinbach,
Manitoba, that
may well have been
built by a former
Maritimer.

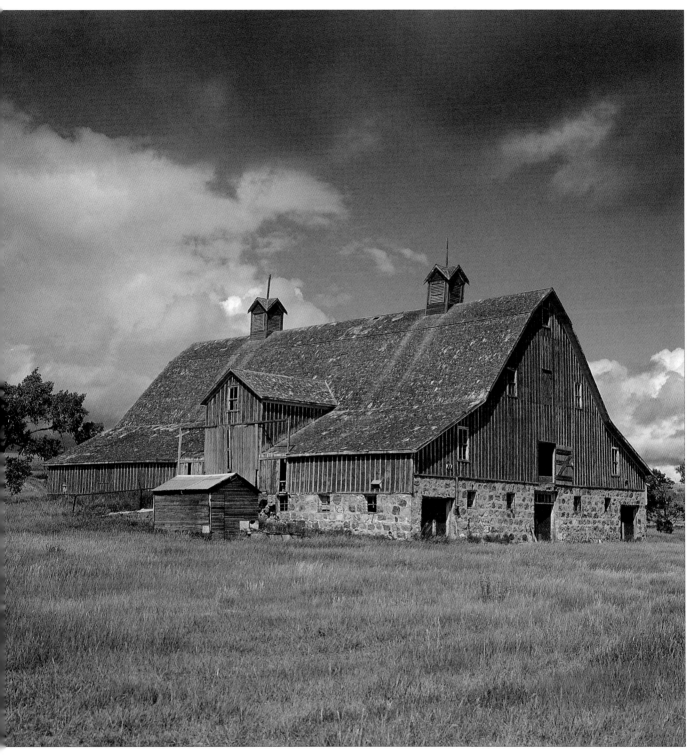

*112. Doune Lodge of
Arcola, Saskatchewan,
home of champions.*

Saskatchewan barn (No. 105) must be one of the grandest survivors. Not only does it challenge the Smith barn for total usable floor space, but it is a worthy representative of the rarest form of barn in the West, the architecturally designed barn.

Generally speaking, only government research stations, universities, municipalities, or the well-heeled horsey set engaged the services of an architect. Barn design was the neglected child of architecture. Also, the functions of most farms were relatively straightforward, and their owners were usually self-reliant types loathe to hire outside advice.

Publicly owned barns were another matter. Not only were they erected as examples to other farmers and businessmen, but they were often objects of civic pride when compared to barns of other jurisdictions. The large University of Saskatchewan barn is an example of this attitude. It is also a vivid testimonial to the status of agriculture in those earlier days.

When the university was first created, it apportioned 292 acres for a campus, 880 acres for agricultural operations, and 160 acres for experimental crops. Between 1910 and 1913, eight major buildings were designed by a Montreal architectural firm, many of them related to agriculture. They included designs for the stock pavilion, farm machinery building, and a large barn.

What a large and magnificent barn it became! Measuring 220 feet along one side of the L-shaped building, and 140 feet along the shorter side, the barn was 50 feet wide and offered students and visitors a rare scene of centralized activity. Its handsome fieldstone foundations and fences were cut from Saskatoon's nearby river boulders and appear in excellent condition today.

It originally housed draught horses and dairy cattle, as well as feed storage. It was more than a barn for education; it was a part of the system required to feed a fast-growing student population. With many ramps leading to its second level, as well as twin silos soaring into clear prairie skies, the design has been emulated on various scales by many farmers across the West.

But like other buildings that were part of the earliest university, the barn is fortunate to have been built at all. When the first sets of tenders were called, low bids were up to 50 percent over the approved budget, and concerns were expressed about delaying or cutting back on either quality or quantity. The university president of the day, Walter Murray, successfully petitioned the provincial government for help, stating "It is, therefore, wise to go forward with confidence and build not for a decade but for a century."

Other existing western university barns also carried a three-fold role in the early part of the 20th century: to inspire working farmers with

excellence of design and functions; to inspire future students and faculty with the best of facilities for agriculture and research; and, equally important, to help feed a hungry university population. These barns can still be found at the University of Manitoba in Winnipeg and the University of Alberta in Edmonton.

Still other forms hold a special niche in western barnlore because of the unusual commodities produced. Examples would include the multi-peaked barns of farmers who provided hops for breweries, or the telltale towers on small stables that signalled fox-farming operations.

Fox towers were needed to manage the brief but critical mating period. Farm help had to stay at observation posts for days at a time without disturbing the rather bashful animals, but also be ready to move the male to another female pen once he had done his required duty. Today, the whole business is one of drugs and artificial insemination, without the peeping towers or their highly individualistic designs.

Market prices attracted several hundred western farmers into fur-farming prior to the Dirty Thirties. Pelts then commanded $300 and $400 each, and breeding stock was exported for up to $1,800 per animal. A decade later, prices were below $15 a pelt and pens were empty.

Social values also played a role in use of farm buildings. At one time enormous barns were required to feed the staff and patients of hospitals and mental institutions across the West. Like the beautiful old dairy barn at the Saskatchewan Hospital grounds in North Battleford, these huge monoliths became unnecessary when the needs of the institutions changed to reflect new community attitudes toward the sick or aged.

Used in design books as an example of what good barn designs should be, the North Battleford structure is less than eighty years old, but has not been used for at least thirty years. Yet it was a special barn at one time — special for the therapy provided to thousands of patients who worked in it, and special for the dignity with which it quietly grows old and unused in a forgetful society.

Show and Sell

Horses were a passion with western farmers, and barns were temples where champions of the show ring or plow received an owner's private homage. Barns were built mainly for horses, and when the era of horsepower ended earlier this century, so too did the age of barns.

Scottie Bryce was typical of the men who loved horses, and whose barn reflected pride in his world-famous Clydesdales. His ambition to become a top breeder in North American show rings was realized early in the new century, and thousands of horsemen would later come to Doune Lodge ranch (No. 112) to watch his champions being trained and bred.

Bryce had trekked to the foot of the rolling Moose Mountains of Saskatchewan about 1882. He began importing proven and potential champions from England and his native Scotland to his farm near Arcola. These gentle

114. Inspecting the line of work horses for sale at McLeans Stables.

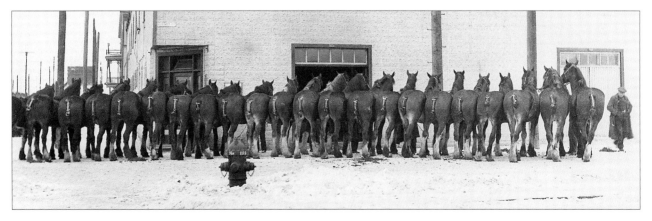

giants captured many honours for their owner, including the prestigious Chicago International.

When not in competition, the Clydesdales were quartered at Doune Lodge in a magnificent large barn almost without equal before or since. Reflecting the substantial landscape around it, the barn was situated on a massive fieldstone foundation almost 100 feet square. Most of the interior was given to screened box stalls for the breeding stallions, as well as feed for them and the handful of workhorses required for Doune Lodge fields.

The Scot spent $10,000 to build his barn for

Experts in the late 1920s estimated that horses worked an average of 500 to 900 hours per year, although some put in as much as 1,400 hours in the fields each year. The average cost per horse was $80 in the Red River Valley, and half as much in parts of Alberta and Saskatchewan. Annual operating costs for tractors ranged between $300 for two-plow models, to $760 for four-plow power.

Plodding along at a predictable 2.5 miles per hour, the 1,500-pound giants pulled many a prairie farmer through price depressions by providing self-sustaining and inexpensive

115. Champions on display at Calgary's Dominion Exhibition in 1908.

champions — a staggering sum of money in 1903, but perhaps not for the Cannington Manor area of Saskatchewan where extravagance by imported nobility often had little economic justification. Nor does it seem inappropriate that a building to house champions should cost only half what some of the individual residents were sold for at annual international sales.

Unfortunately, economic forces that eventually choked the passion of prairie horsemen were just as obvious. Experts preached the inefficiency of giving over to feeding purposes at least three acres of crop per horse, and as much as eleven acres of pasture per horse. The drop in horse numbers between 1918 and 1930 meant another 2.5 million acres of crop revenue or feed for other markets or farm animals.

power until prices recovered. But despite the needs of war and depression, the horse population of Western Canada peaked at 2.5 million about 1921 and has fallen steadily thereafter.

But if barns were, and still remain, a necessary fixture for those involved in the showing of horses, they have also been an integral part of institutions that sold farms and farming methods, for example, the Canadian Pacific Railway barns across Western Canada. At Strathmore, Alberta, the Canadian Pacific Irrigation Colonization Company spent enormous sums of money to build a farm that would demonstrate new techniques, as well as break and seed large tracts of land for settlers who would be buying ready-to-farm packages from the CPR.

Its barns were built in the period 1905–10 and were straight from the drawing boards of rail-

way architecture, and built largely of railway materials. Long rows of windows, enormous 12-inch cedar beams normally used for rail ties, but in this case laid one on top of the other, and large ventilation cupolas were features of some barns at Strathmore that would not be found elsewhere in the West. As railway land began to fill up with new settlers, the farm became less of an educational agency for the land developer, and more of a supply farm for dairy, poultry, and vegetables for the company's national hotel and dining railcar departments.

One can find the railway influence at other points in early western barns. In Winnipeg, for example, the CPR joined with Canadian National Yards in 1913 to build the sprawling Union Stock Yards, and the nearly forty barns (Nos. 117, 118) required to marshall livestock shipments for export. Most of these barns were identical in 125-foot-by-50-foot size and design. Their monitor shape featured long rows of windows high above the livestock pens, and wide alleys to easily accommodate moving blocks of cattle at one time. Annual volumes of one million head shipped through the Union Stock Yards were not unheard of during the heydays of the 1940s and early 1950s.

Just a few miles down the Red River toward East Selkirk is another example of railway influences in farm building design, this time from the

116 & 117. The before and after photos of the Winnipeg Union Stockyards taken in the heydays of the 1920s and the dismal days of the 1980s.

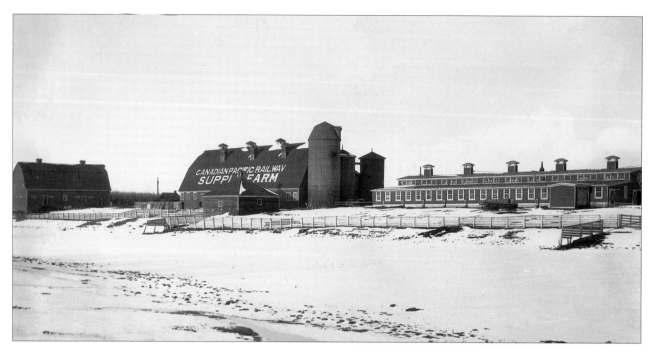

very top. Sir William Van Horne created a 10,000-acre farm near the town which most people thought would become the divisional headquarters for the railway. That honor later went to Winnipeg, but the Van Horne farm in time became one of the most highly regarded operations in the province, an almost compulsory annual tour for university agricultural students.

Again, the buildings could easily have fit into a railway yard with their cottage roofs, dormer ventilation, long rows of sidelighting, large

cupolas, and, of course, the deep-red colouring. The few original buildings to survive are perhaps best represented by the small implement shed-barn (No. 119) still in use today.

But which western barn has been seen by more people than any other? That honour probably goes to a barn that is not very old, that is indistinguishable from thousands of other barns almost identical to it, and that was forgotten almost as soon as it was seen by millions of people around the world. The barn (No. 121) is that of Superman—or Clark Kent, if you will. Located on a knoll southwest of Blackie, Alberta, this small barn was part of the quiet movie backdrop where a young man was raised by foster parents to know values that would later serve him so well against forces of evil.

The barn had a small, supporting role. It was part of the symbolism of grassroots America, offering comforting but strong solitude for a young man knowing grief for the first time through his foster father's death. Like too many other barns, its usefulness in real life was brief.

Historic Places

For seventy-five years, the Boyd family watched gold-thirsting men and their beasts struggle past the door, hurrying toward the elusive riches of northern British Columbia goldfields, most of them eventually returning with broken dreams and empty pockets. Much of the traffic halted briefly at John Boyd's Cottonwood House near Barkerville, which today is one of the few remaining roadhouses along the famous Cariboo Wagon Road, and includes some of the oldest buildings in the province. Paying customers in those days found shelter and food for themselves in the roadhouse, and for their animals in one of the several log barns and stables (No. 122) at Cottonwood. As often as not, the animals would also be sharing their barn accommodations with the non-paying traveller seeking a free bed of straw.

In the big double barn, built shortly after the main house was finished in 1865, one would normally find the horses, mules, and oxen used as freight or packing animals. Sitting in the sheltered passageway or nearby would be the bright yellow and red freight wagons or passenger coaches of the famous B.X. express line, which at the time might haul someone from Ashcroft to Barkerville for $42.50 (winter rate), or $37.50 (summer rate). Each passenger was allowed up to forty pounds of luggage.

The Boyds housed their own farm stock in small stables. The abundance of good pasture land provided excellent feed for milk cows or work horses, which in turn helped produce food supplies for other farmers and miners in the area.

Cottonwood House was only one of many roadhouses to serve the needs of the Cariboo Wagon Road and the B.X. stage line, which used the big four- and six-horse teams for their concord stages, and two-horse rigs for the shorter runs. But with the last mail run in 1915, these colourful freighters disappeared from the Cariboo Highway.

John Boyd died in 1909 and did not witness the end of this era. However, his family continued operating Cottonwood House until 1951. It later was named a provincial historic park and restored to earlier conditions.

It is not surprising that protection and restoration by public and private agencies has saved only a handful of historic western barns to date. Another example is the Egge stopping house and barn relocated in Fort Edmonton Park (No. 124), but originally a part of the Athabasca Trail north from Edmonton to new settlement areas. The Egge barn is noteworthy as an important part of the services offered travellers, but equally important as one of the rare examples of Pennsylvania barn buildings in Western Canada.

Newton Egge is believed to have been raised in Pennsylvania, farmed near the Minnesota-Wisconsin border, and homesteaded on the Athabasca Trail about 1898. The Egge family began its stopping-house services about 1903, charging 50 cents for sheltering and feeding a team of horses overnight or 15 cents for a noon feeding of hay.

The Pennsylvania Dutch barn was constructed of large logs for the lower walls, and frame for the second level. It had two main features: a capacity to house twenty-five to thirty teams of horses at a time; and an enormous

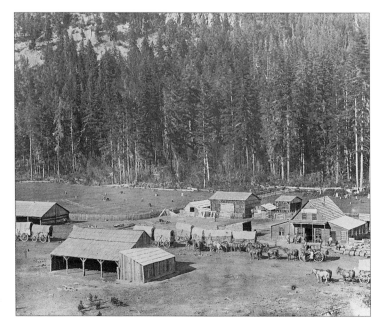

120. The line of freighters was long outside Boothroyd's Hostelry in 1868 as men and equipment headed for the northern gold mines. Located near Hell's Gate, British Columbia.

121. The humble
setting for a
Superman movie
near Blackie,
Alberta.

122. Completely
restored barns
and stables at
Cottonwood
House, one of the
few remaining
roadhouses along
the Cariboo
Highway.

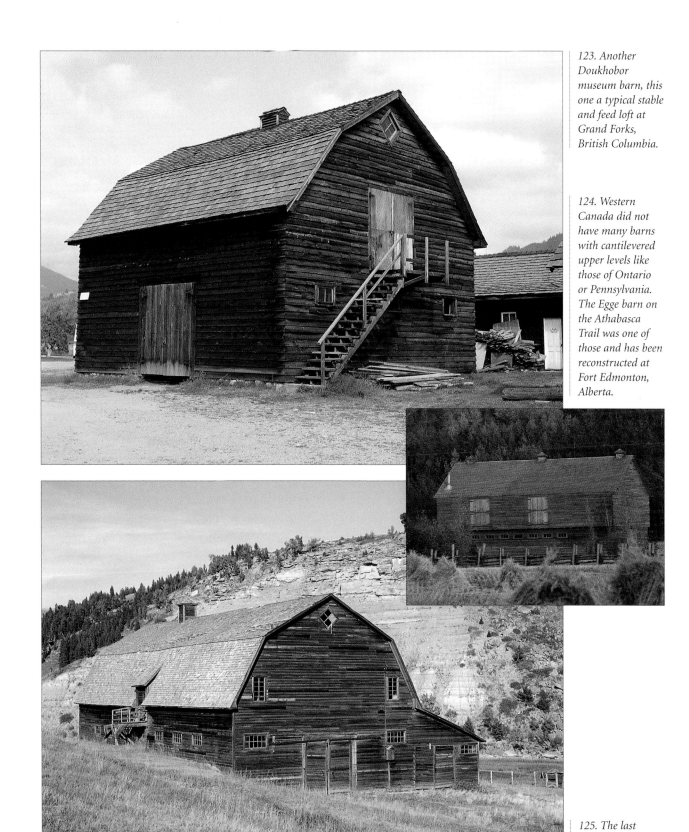

123. Another Doukhobor museum barn, this one a typical stable and feed loft at Grand Forks, British Columbia.

124. Western Canada did not have many barns with cantilevered upper levels like those of Ontario or Pennsylvania. The Egge barn on the Athabasca Trail was one of those and has been reconstructed at Fort Edmonton, Alberta.

125. The last communal barn at Cowley, Alberta.

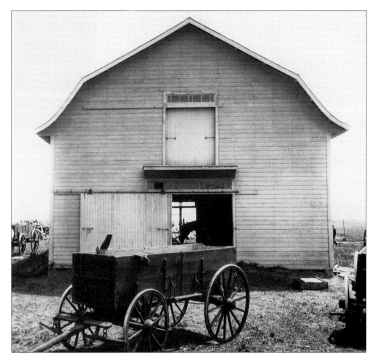

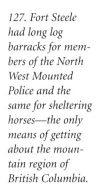

126. A communal barn for Douk-hobors at Veregin, Saskatchewan, used to stable horses when farmers brought loads of grain to the local flour mill.

127. Fort Steele had long log barracks for members of the North West Mounted Police and the same for sheltering horses—the only means of getting about the mountain region of British Columbia.

War, when new roads and vehicles made the Egge stopping-house unnecessary.

If Cariboo Road and Athabasca Trail barns often sheltered the ambitions of men seeking riches in isolated goldfields, then the barns of the Doukhobors reflected a search for a different kind of wealth: freedom of religious belief.

When the Doukhobors first arrived in 1899 to settle near the Saskatchewan-Manitoba border, the building traditions of their Russian homeland were faithfully repeated. Families clustered in village-like communities, sharing a large central barn or two for animal and feed shelter. As pressures grew to build and farm on a more individual basis, as well as to assimilate into the larger social fabric, many Doukhobors left their thatched farm buildings to find a more peaceful existence in the mountainous isolation of British Columbia. Here the buildings reflected a more progressive attitude to materials, design, and ownership.

One final move by the Doukhobors brought them to the Cowley area of Alberta about 1915, and one more attempt to create the communal spirit of ownership and freedom from external social pressures. In 1916, the Christian Union of Universal Brotherhood built its last communal barn (No. 125) and nearby wooden bathhouse. A hardwood structure of modern design and proportion, the barn material came from a Doukhobor lumber mill in British Columbia. As

upper level capacity made possible by the extended forebay or overshoot. This cantilevered level was very similar to the design originating in Pennsylvania and Ontario more than two hundred years ago, but not transferred to many western barns.

Whether the occupants were teams hauling freight or fur trading supplies, or teams for settlers heading into northern Alberta, the Egge barn and two smaller stables were nearly always full. It continued its role until the Second World

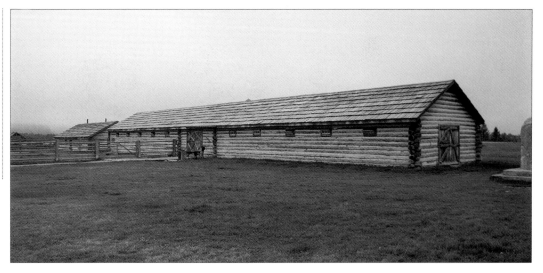

more members took up individual farms, the sect ceased its pursuit of communal farming and tended to the community's spiritual well-being only.

Whether providing shelter for horses of the North West Mounted Police outpost at Fort Steele, British Columbia (No. 127), or at the force's headquarters back in Regina (No. 108), or serving the pleasures of princes, premiers, or official representatives of kings and queens, the barns of Western Canada were part of the birth, adolescence, and maturity of half a nation.

128. One of several barns on the E.P. Ranch, Pekisko, Alberta, in the 1920s, then owned by His Royal Highness The Prince of Wales.

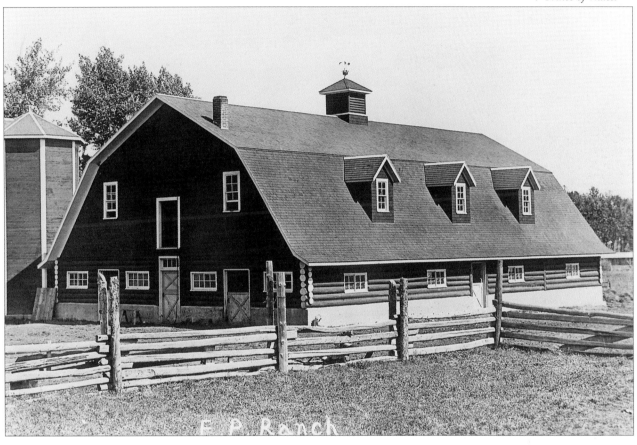

E P Ranch

*129. Misty mountain moisture
near Golden, British Columbia.*

Land and Climate

During the major settlement era, the governments of Canada and its western territories spent millions of dollars telling Europeans and Americans about the wonders of the West and the free land and agricultural fortunes to be harvested. Yet it remained the "Great Lone Land" to most outsiders and insiders alike—a most formidable stretch of prairie and mountain, tormenting in promises never quite fulfilled.

Climate dictated most everything in the West: crops, styles and materials of buildings, travel, and general economic progress. On the lower flatlands of the prairies, wind was the constant antagonist, accelerating drying and cracking both in summer and winter. In the bushlands that separated prairie grass from granite-like northland, marginal soils proved a poor springboard for crops or forest resources. In the mountain regions and beyond, moisture extremes of snow or rain became both a boon and a threat to farm operations.

In all regions, farm buildings were designed as a defence against the elements. On the flatlands, barn roofs tended to be longer and more gently sloping in order to better combat the constant winds. Windmills were incorporated into barn designs for watering livestock or grinding power for milling. "Shelter-belts" along the northern perimeter of a farmyard, or barns built in a south-facing slope were other defences for

The many substantial, commodious farmhouses and barns to be seen throughout the country are, perhaps, the most convincing testimonials to the productivity of Western soils. They speak of wealth taken from the land and converted into structures of brick, stone and wood. They are properly the first fruits of the virgin plain, and they stand as interrogation marks, if one reads their meaning aright. They ask the question, "What has been returned to the land in compensation for this production of wealth?"

THE FARMER'S ADVOCATE, 1905

farmers both then and now. Board-and-batten overlap for vertical siding became a popular method of covering barns that would suffer wind-inflicted wood shrinkage.

In the bushlands, log tended to be the quickest, cheapest, and most available material for farm buildings for every need. Because of the slow maturity of trees in those climates, smaller logs meant smaller barns, less permanent designs, and little in the way of sophisticated layouts. While the same limiting resource tended to produce less productive crops, it nurtured a higher level of self-reliance and individual innovation.

Meanwhile, the mountains dictated their own design modifications. Steep roofs to handle

130. A sweeping gambrel roof near Oxbow, Saskatchewan.

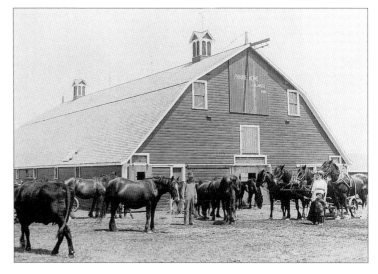

93

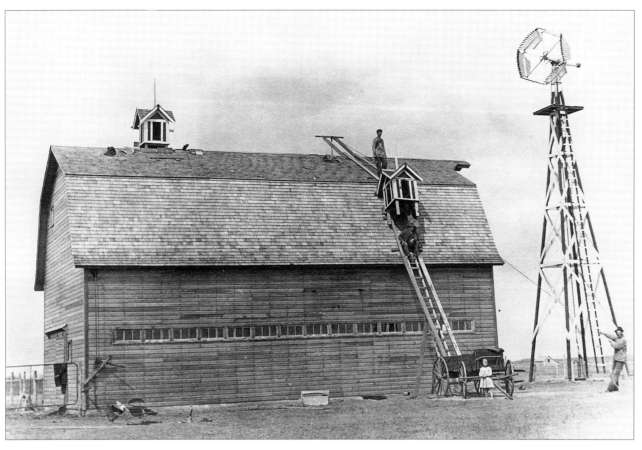

131. Sloped roofs were turned to face prevailing winds that could rip cupolas or windmills from roofs.

snowfalls were an obvious requirement for most areas, but also had a double benefit of producing a more voluminous loft for storing extra winter feed. Huge timbers were available to stretch barns to greater proportions than elsewhere, as well as give strength and durability to the main structure. Perhaps because of the type of settler, perhaps because of the rugged assurance required by the most isolated farmers in Canada, there was little in the way of unnecessary decoration on their mountain barns.

The barn was an important part of conquering the Great Lone Land. Today it is the conquered, a symbol of abandonment.

The Flatlands

Until the mid-1970s there was a barn several miles east of Piapot, Saskatchewan, that at one time featured an unusually tall tower on the roof. It was the site of the former headquarters for one of the largest farms in Canada's history,

known by several names including the Crane Lake Ranch, or 76 Ranch, or more formally as the Canadian Agricultural Coal and Colonization Company.

It consisted of eleven distinct ranch operations, each about 10,000 acres in size. Each evening, or so they say, a ranch-hand would climb to the top of the Piapot barn tower from which he could see for miles in every direction. Yet the thousands of cattle within his view represented only a small part of the cattle empire. Only on the flatlands could one hear such a story.

Unfortunately, the same flatness helps create wind—the worst enemy of barn builders. Perhaps more than any other single force, including the dreaded prairie fires of early settlement years, wind destroys or damages millions of dollars worth of farm buildings each year.

The defensive measures are easy to recognize on some barns. The long roofline of a barn (No.

133) near Melaval, Saskatchewan, shows one common-sense defence against the never-ending winds of the region, but it also shows the rusting effects of a climate with extreme swings in moisture and temperature.

One might say that the original owner, Louis Perry, had other design innovations worth noting. The CPR branchline went through the area about 1912–13 and one day found itself unusually short of rail ties. The materials were tracked down to the Perry barn, where one of Western Canada's most substantial wooden barn floors had just been completed. The barn owner spent thirty days in the cooler for his innovation, and later was to die tragically when knocked down by a runaway team of horses.

But wind was also a provider to flatland farmers. Roof windmills were once a common part of barn designs, providing free power to drive water pumps, electrical systems, or grinding stones. Fewer than one in ten have survived to the present, and the stubs of former windmill platforms are now a common sight.

An example of the lifting power of these wind-driven machines might be taken from the Macklin barn near Clandeboye, Manitoba. Built more than 65 years ago by C.E. Fillmore, it is one of the few roof-mounted windmills to survive the fierce windstorms that lash the Lake Winnipeg regions. Until the 1950s, the windmill was in daily use, mainly for filling a 2,000-gallon holding tank in the upper levels of the barn.

Round or circular-styled barns are another feature almost exclusive to the prairies because of reputed abilities to deflect winds more easily than their "boxy" cousins. Few of these styles found favor in the bushlands or mountains where materials did not lend themselves to the complex construction techniques needed for circular building.

Side walls also tended to be only as high as thought necessary, thus reducing exposure to winds. In certain regions, these shorter walls were often accompanied by large gambrel roofs, which were sited to bear the brunt of prevailing winds.

132. Pig barns at St. Norbert, Manitoba.

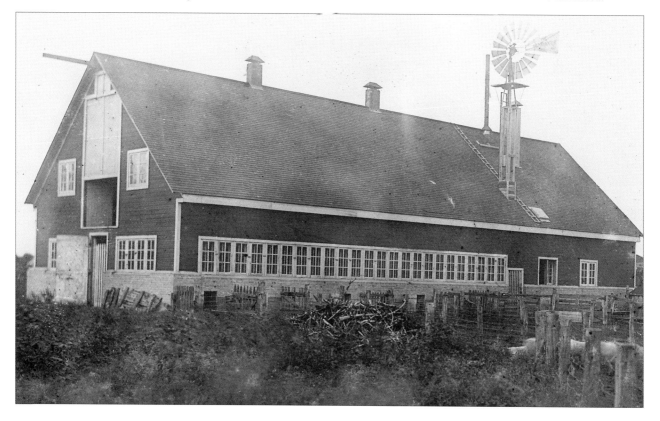

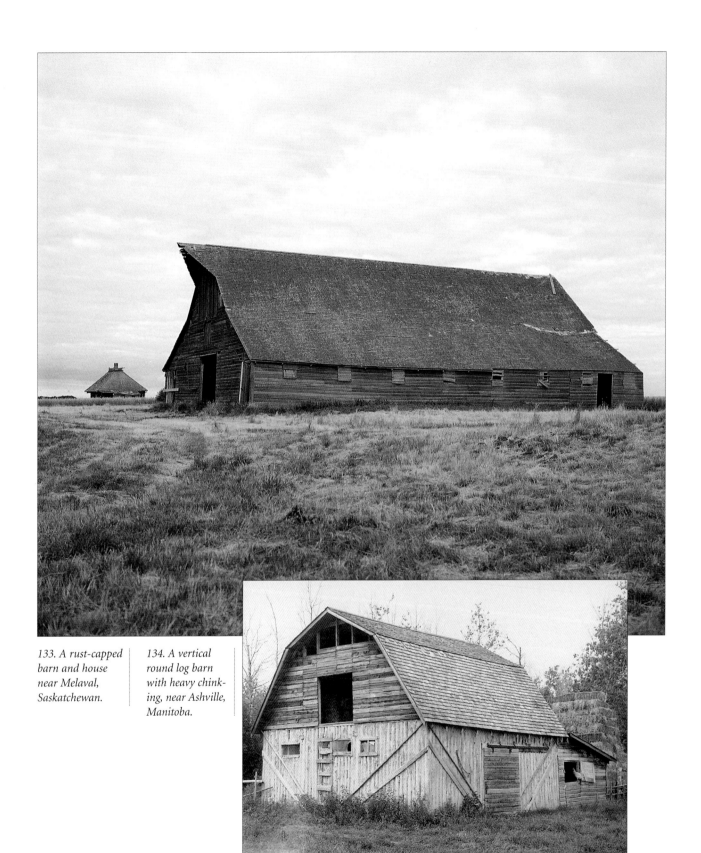

133. A rust-capped
barn and house
near Melaval,
Saskatchewan.

134. A vertical
round log barn
with heavy chink-
ing, near Ashville,
Manitoba.

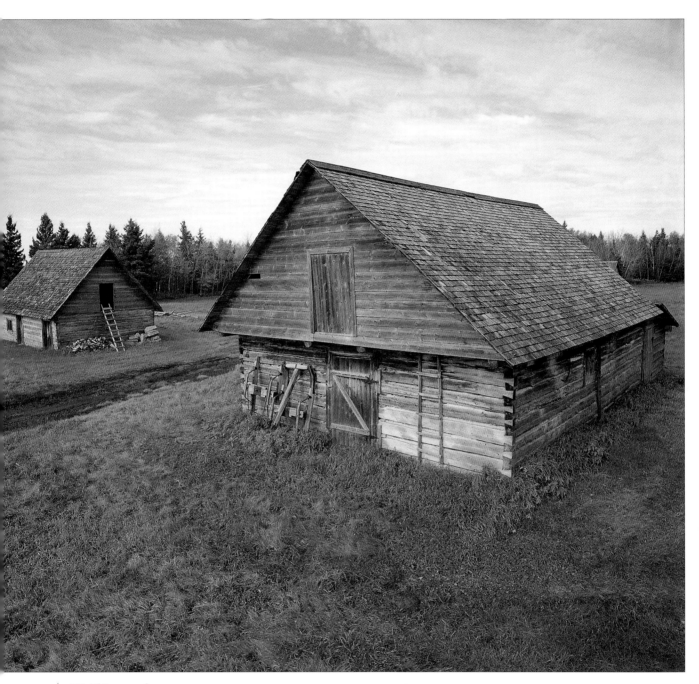

135. This squared
log barn near
Poplarfield,
Manitoba, shows
dovetailed corners
on stable and shed.

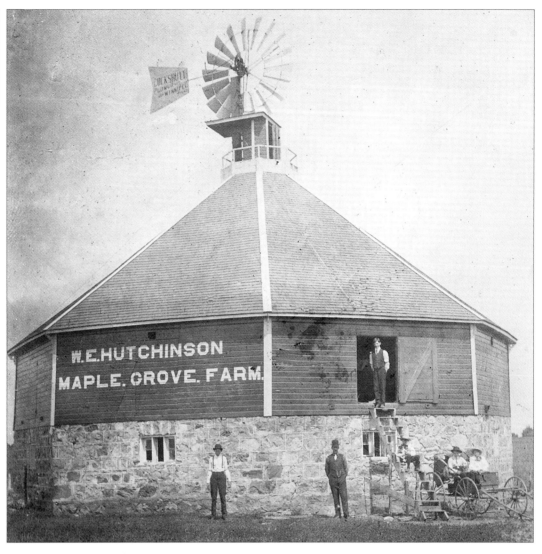

Other features more often found on the flat-lands include the board-and-batten treatment for vertical siding, fieldstone foundations, larger overall barn proportions to reflect larger scales of farming, as well as greater use of factory-made materials for framing, roofing, or interior convenience.

Board-and-batten was a technique imported from Ontario that allowed the use of narrow boards to cover the gaps that invariably appeared between the broad vertical pine boards favoured by farmers. In other parts of North America such gaps were generally encouraged, as they brought drying effects to crops such as corn and tobacco. On the prairies, however, the fall or winter wind could ruin a farmer by forcing moisture into precious winter feed stocks or seed grain.

Unlike farm buildings in other parts of the continent where the climate is more temperate, the flatland barns faced blistering heat in the summer and wood-snapping cold in the winter. Wood exteriors could not stand up to a see-saw climate without protective oil-based coverings. This partially accounts for the more colourful exterior decorating of prairie farm buildings compared to those barns in wooded western regions where natural finishes were often sufficient.

A study of barn buildings in western

Manitoba provides a clear picture of building throughout the flatlands since this region encompasses topographical characteristics of the prairie as a whole and experienced an early settlement period, as well as the boom times of the early 1900s.

The first barns were no more than log sheds, rough and built quickly to shelter a small number of livestock. Most were one-and-a-half-storey stables that were converted to other storage duties as soon as herds grew and better materials were available to build a new barn.

Frame construction had arrived in the region by 1880, although the style of building continued to be relatively small and rectangular. As the economic climate began to improve across the West, many settlers simply added to existing barns to create L-, U-, or T-shaped barns.

Bank barns also came into favor about this time, first with fieldstone foundations that supported the heavier post-and-beam style brought from Ontario, then with cement just before the turn of the century. The structures almost doubled in size about this time, as wheat economies boomed. Gambrel roofs provided larger storage capacity in lofts, and stable areas received an additional alley and storage area.

Root cellars and foaling and calving pens also became part of popular designs. Hayslings made their dramatic appearance at the turn of the century and helped farmers do away with building ramps to the second level, or digging bank barns into sides of hills. The sling and trolley lifted hay loads through gigantic gable-end doors, thus allowing complete redesign on the ground floors as well.

Plank framing was also introduced to replace heavy main frames, while materials such as metal siding, bricks, blocks, and ready-made packages completed the transitional period. Except for a few minor wrinkles added by individual farmers, the barn was in its final form.

The Bushlands

If permanence and largeness were to become features of farm buildings on the flatland, then convenience and smallness would be words to describe farm buildings found in the bushlands that ringed the prairie provinces.

This was the last refuge of the fur trader, who watched immigrants from Eastern Canada and the United States grab the practical cropland. The bushland also attracted large numbers of late-arriving settlers from Eastern Europe. They were able to start with less cash than their flatland neighbors, but in the end paid a larger cost because they had to work two and three times as hard to get the marginal bushland to produce the same net benefit.

The earliest farm buildings in Western Canada were in the eastern bushland fringe. Historian Alexander Ross wrote one of the most detailed descriptions of such premises and often described the condition of agriculture with painful clarity. One such description followed a visit to an old friend's farm and his subsequent tour of the barnyard:

The first place we went to see was a miserable sort of hovel, without lock or latch, with the snow drifting through the roof, which the old gentleman called his barn. It was just large enough for two men to work in, but they preferred the ice-floor on the outside, as being safer, and hardly more exposed, since a cat jumped out between the logs as soon as we got in; and for that matter, a dog might have followed her, the holes being ample enough . . . Leaving the barn, we went to one of the stables close by; but I saw enough of it from the outside to satisfy me, without going in. The door had first been on the east side of the building; but when that had got choked up with dung, one had been cut on the west end, then on the north, and as a last make-shift, when I was there, one was cut on the south side, fronting the dwelling-house door, and not

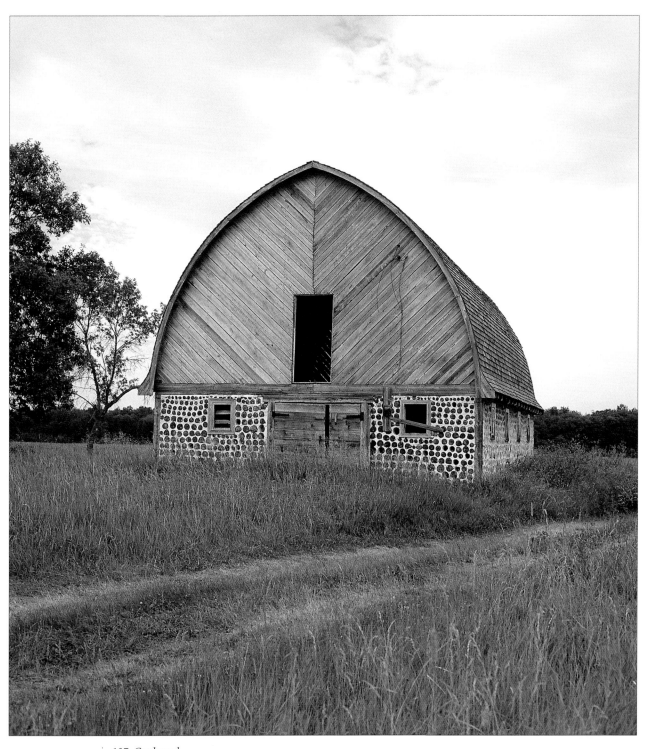

*137. Cordwood
sidewalls at
Camp Morton,
Manitoba.*

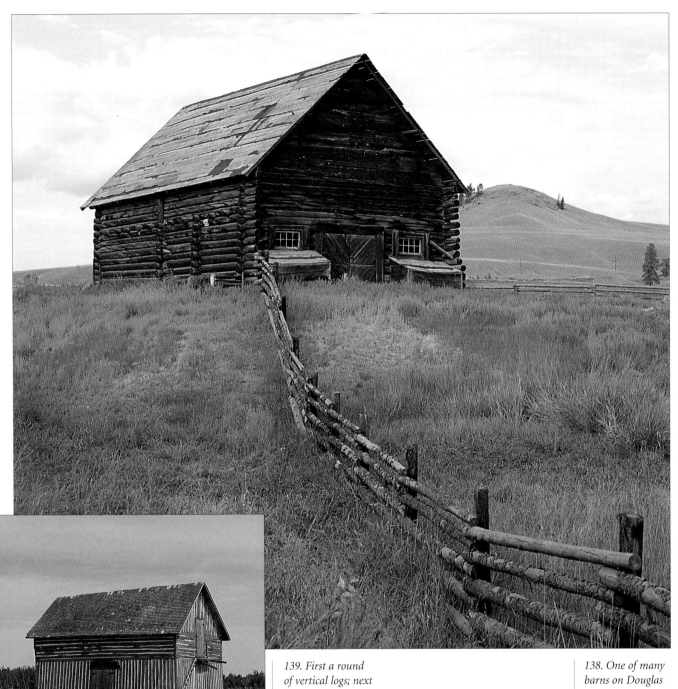

139. First a round of vertical logs; next eight layers of horizontal logs for the second level; and finally, vertical logs again for the gables. Hazel Dell, Saskatchewan.

138. One of many barns on Douglas Lake Ranch, British Columbia.

many yards from it; at the same time dung was piled so high all round, that nothing of the building, except the roof, was to be seen. To reach the door, the animals had to slide down, and get out on their knees. On my observing this difficulty of ingress and egress, the old gentleman remarked, "Losses do now and then occur; we have, however, lost but one this season." When I asked him where he would cut out the next door, seeing no place accessible but the roof; "Oh! We will throw the building away," said he, "and make another."

But if the bushland did not encourage permanency in farm building design at the start of the settlement periods, it did encourage some innovative uses of native materials. If wind was the common enemy of flatlanders, immature timber was the bane of bushlanders, and resulted in distinctive farm structures.

One such style was a method that went by many names including stackwall, cordwood, log-butt, stovewood, or log-end construction. Its North American origins have been traced back about two hundred years to the Ottawa River Valley between Ontario and Quebec. (In Siberia and Greece, cordwood structures are estimated to be more than one thousand years old,

but no one can say with certainty where the method originated.)

The examples still remaining in Western Canada date back to the 1920s and 1930s, although cordwood barns and houses built between 1850 and 1890 have been found in Wisconsin and other northern states. The method featured round or squared logs cut to a uniform length of between eight and twelve inches. The wood was laid into a lime-cement mortar with the one end exposed to the weather. Walls were built to required height in the same manner of fieldstone or brick masonry.

Relatively cheap in cash outlay, the technique had the advantage of being fast, strong, and reasonably warm. The problems included uncertainty about durability and the shrinking and expansion of logs after long periods of moisture or dryness. Windy draughts could result. The idea never caught on with Western Canadian farmers; one reason may have been the relatively scant attention paid to cordwood construction by the media of the day.

The other style of barn building exclusive to the bushland was that called Red River frame, or post-and-fill. It became popular because it utilized shorter timber and was also somewhat more flexible for future expansion.

The style consisted of larger timbers cut to required ceiling heights and then squared. Grooves were then cut into two opposite sides and the timbers anchored to either corners or along the sides of the planned wall. Shorter timbers were then squared and the ends tapered to fit into the vertical grooves. This style of construction can be found in many other parts of Eastern Canada, as well as parts of northern Saskatchewan and Alberta. Instead of cutting a groove into the vertical support timber, larger planks were sometimes nailed on each side to provide a channel for shorter wall pieces.

Log barns continued to be built in the bushland regions until the 1940s, although frame construction had long since become the preferred method.

140. A close-up view of stackwall construction.

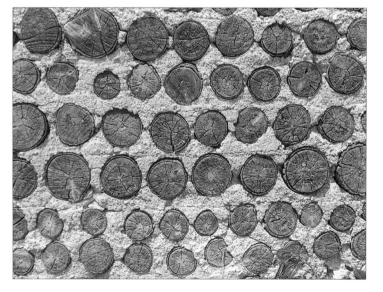

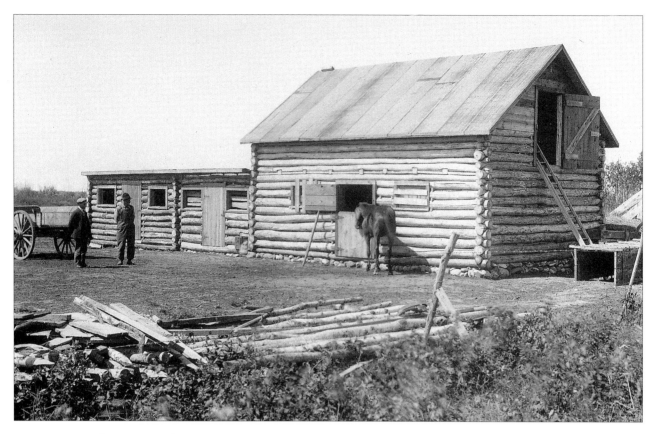

The Mountains

The contrasting styles of the farm buildings built by John Bunyan Ray and Joseph Blackburn Greaves spoke volumes about ambitions and lifestyles, as well as the extremes of settling within British Columbia's varied mountain terrain. On the one hand is a tiny farmstead located in the heart of one of the province's wilderness parks. On the other hand is an operation where one can spend almost an entire day just travelling the ranch property.

John Ray spent his first twenty years in Canada trapping and hunting the isolated wilderness that today is known as Wells Gray Provincial Park, a region only slightly more developed now than when he first arrived there from North Carolina. He acquired a small acreage in 1929 and began a small farm operation in an area better known for its thundering waterfalls and severe winters. The small log cabin and log barn (No. 142) were easily built with the unlimited timber resources at hand,

characterized by strong, simple construction techniques not unusual for wilderness shelters.

Ray and his wife remained at arm's length from civilization for almost two decades, raising three children in that time, plus continuing a mixed farming-hunting lifestyle. His death in 1947 symbolized his preference for isolated farming. He was caught between the barn and house during a blinding winter storm, alone because his family happened to be away from the homestead at the time. Ray is buried beside a birch grove on the abandoned farmstead, the only marked grave in the 13 million acres of wilderness provincial park.

At the other end of the farming scale was Joseph Blackburn Greaves, son of a British butcher who at the time Ray was first setting foot in the British Columbia wilderness, was just stepping out of it. In this case, however, stepping out meant selling what was then considered to be Canada's largest ranch, the Douglas Lake Cattle Company.

141. A horizontal peeled log barn and feed storage sheds with saddle-notch construction near Langruth, Manitoba.

142. The wilderness farm of John Ray in Wells Gray Provincial Park, British Columbia.

143. High, open gables are a consistent feature of mountain barns, such as this one near Alexandria, British Columbia.

144. Fog encloses a typical landmark of the Fraser Valley, the twin silos of a dairy farm.

145. This barn near Rorketon, Manitoba, shows Red River framing techniques, with additional bracing.

146. Lord Aberdeen's Coldstream Ranch near Vernon, British Columbia.

Greaves's was the kind of story of which movies are made: hiding out on a British ship for North America, trekking across the continent to California, then trailing north with cattle herds, becoming a Western Canadian cowboy. By the 1860s, he and several others in the Upper Nicola River region, including John Douglas, who homesteaded the Douglas Lake area in 1872, had started various ranch operations. As the transcontinental railway crews pounded across the prairie, the demand for beef increased and Greaves kept buying out neighbours until his operation became Canada's largest cattle empire.

He died in 1915, a few years after selling to another British family, who sold to two Canadian industrialists in 1950, who in turn sold Douglas Lake Cattle Company in 1962 to C.N. (Chunky) Woodward, chairman of the Vancouver-based Woodward stores.

About 15,000 head of world-quality Herefords can be found on the delicate ranchland, about the same numbers allowed by Greaves back in 1893. Douglas Lake Cattle Company is renowned for its quarter-horses, and buyers from all corners of the globe are attracted to its annual horse or cattle auctions.

To say the Douglas Ranch had a few barns (No. 138) is like stating that British Columbia has a few mountains. The almost exclusively log structures are scattered throughout the half-million-acre spread. Reflecting the individualism of their original owners who had come from other countries, from rail gangs, prairie farms, city banks, or bankrupt nobility, the barns were mainly shelter for quarter-horses and dairy livestock. Many have stood up

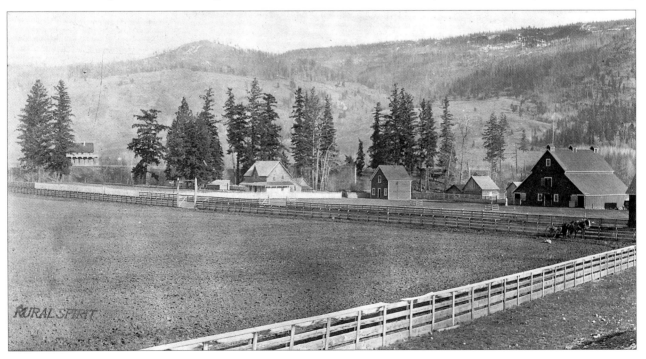

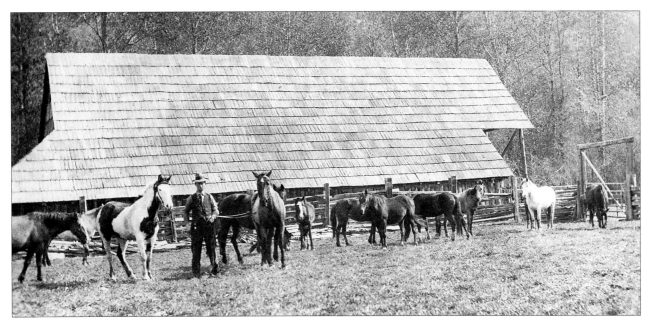

well against the heavy snowfalls and intense summer heat of the region—aging gracefully in a process unique to British Columbia log barns.

At one time the Douglas Ranch boasted more than one hundred barns and stables. Most of these are located in remote corners of the spread. Even if they were more accessible, their true beauty would best be appreciated at a respectful distance. Like all farmers, Kamloops-area cattle ranchers value privacy.

To think of British Columbia log barns as having a sameness would be a mistake, as any trip along the famous Cariboo Highway will quickly demonstrate. It was over this 280-mile wagon road that an estimated $100 million in Cariboo gold passed to southern markets. Whether heading to or from the goldfields, man and beast relied on the historic roadhouses for food and shelter during the four-day stage journey.

Boasting logs two feet in trimmed thickness, these barns often reached unusual length because of the number of teams that required nightly lodging. Continuous log walls of more than eighty feet were not unusual.

The most striking feature of log barns in the province is the steeply pitched gable roof, a practical reaction to the staggering snow loads that characterize much of the terrain. Often open under the gable peaks for better ventilation, the shapes also provide larger capacities for winter livestock feed.

Unlike on the prairies where suitable timber resources quickly disappeared under the axes of early settlers, British Columbia farmers are rarely far from excellent timber resources or milling facilities. For this reason, log barns continue to be built in many parts of the province when economic circumstances turn sour or uncertain.

But if the mountain barns offer simple reflections of use and materials, the barns of British Columbia's Lower Mainland region suggest sophistication. With the picturesque dairy barns of the Fraser Valley leading the way, the structures follow the lines and interiors of their prairie cousins. Likewise, these barns are not dissimilar to barns in the eastern coastal regions of Canada, with cedar shingles a popular exterior cladding, and silo towers signifying a proud dairy operation.

147. The styles and needs of ranches haven't changed much in 90 years. Neale Ranch, Pemberton, British Columbia.

Barn Notes

Change continues in the farmlands of Western Canada, just as it continues in all agricultural communities across North America. For the most part, the change is more of a forced march. It pushes more often than it leads. It distills values from financial figures rather than bedrock beliefs about family and neighbours. The "me-first" generation is taking over farming, bringing a hard edge and sharp city tone to matters of business and community. However, their ideas and questions promise the eventual betterment of farming and economic security for families.

There was once a magnificent old barn that was torn down because a gasoline company wanted the land it stood on and paid a huge sum for it. A local historical society had a plaque made and erected nearby, telling about the barn and its history. But a sense of history is an apology for the absence of beauty; it is in no way a substitute.

ERIC SLOANE, *AN AGE OF BARNS*

Lessons from past mistakes are being discarded. People with depth of understanding and experience find themselves uncomfortable with the future they had worked for. Symbols of the so-called "good old days," such as barns, are still plentiful, but these architectural storybooks are fast disappearing.

Where does the barn fit into the future farmyard when it barely has a toehold in most farm operations of today? It seems highly impractical that anyone would even think of preserving all the beautiful old barns that dot the countryside, although it does seem equally

148. This early barn from Peace River country was originally a log house for settlers.

KIRBY

ridiculous that very little action has been taken to protect the very best. Something has to be done to sharpen the focus on these storybooks of our heritage and give leadership to the many who cherish old barns and feel frustrated by the inertia that inhibits restoration and preservation.

The following pages provide a tiny glimpse into the people and conditions that helped produce each barn. Note numbers are keyed to the photograph numbers in the text. In some instances numbers have been omitted because insufficient additional information was available to the author; in others, the notes had to be pared down because the story of some barns could more than fill an entire chapter.

(3) Nothing was left unused for long on small land holdings, not even stones culled from the fields. In England, small- to medium-sized stones provided material for gradual build-up of fences and barns over long periods of time. Walling is an ancient craft, predating the Roman occupation of Britain, but it was the enclosures of the eighteenth and early nineteenth centuries that led to a great upsurge in the building of walls, mainly in the north of England, the Cotswolds, Wales, and Scotland, where they form a conspicuous element of the landscape. Local variations in building methods may be imposed by the type of material available—limestone, sandstone, or millstone—and the art of the builder lies in an ability to work with irregular materials and in the careful selection, gradation, and placing of each piece of stone. The wall is raised on a footing of large stones laid in a shallow trench, and narrows as it rises. The two outer layers of stone are inclined slightly downwards from the centre to throw off rain, the centre space being filled with a hearting of small pieces. Single stones at intervals pass right through the wall to bind it together, and the coping is formed of thin, flat stones placed on edge. No mortar is used in the construction since water would freeze in the cracks of a cemented wall and force the stones apart. The waller relies on the adhesion of the rough stones and their own weight to settle and strengthen the wall, which is allowed to remain open to the drying winds.

(4) The link between the design of churches and tithe barns is clearly struck in examples such as this with its "basilican" floor plan—a large central nave and aisles along each side for livestock or feed storage.

(6) Ageless stone construction was common to a large number of farming nations that used the material for shelters large and small. This photo from Ireland shows two sheds or barns almost hidden by the house. All three feature thatch woven with rope and held down with rock weights along the eaves and gables.

(8) Man and his farm animals also shared this house-barn, now part of a living museum in Germany. In this style, the farm family lives at the far end of the building and has two storeys of rooms. The brick nogging was popular in different areas of old Germany although generally reserved for well-to-do farmers.

(9) The fill-in between tarred timbers is mainly large bricks or frior stones. Each side of this Jutland barn has a lean-to shed running the entire length, although one side has doors at both ends so wagons and carts can take their loads the length of the barn during busy harvest seasons.

(10) A log foundation has supported this Norwegian barn for more than a century. The double ramp allowed teams to enter one side of the upper level and exit down the other ramp.

There was little elbow room for either the driver or his team to manoeuvre once inside the upper storage area.

(11) The sod roof, expert log fitting, and layout help identify this barn as a typical design for many centuries on small farms in Norway. Unlike many designs with a central threshing floor and storage areas for fodder on each side, this barn features only one storage area. It is now part of the Norsk Folkemuseum near Oslo.

(12) The ability of Finnish farmers to fashion handsome and almost airtight buildings is evident in this two-storey granary and hay shelter. A highlight of the granary is its excellent lock-notch corner work.

(13) A steeply pitched stable near Nagyvarad, Romania. The drive-through also acts as a corral for oxen, while wagon shelter is provided on the left and grain storage on the right of the passway.

(15, 16) A before-and-after sequence of photos showing how thatch was applied to pole rafters, and wattle sticks woven into wall poles. The quickly built livestock shelter was further protected from wind or rain by using a plaster-like substance called daub. Door hinges were most often leather strips.

(17) Ventilation forms were never more artistic than in the lattice-like craftsmanship on this long granary in Austria. The granary allows storage of diverse crops in its many sections, some with door arches featuring the wood-scrolled name of the farm owner.

(19) The stone foundation supports a large hayloft, with loads normally hauled up an earth ramp at the rear. The lower level is used for cattle stabling.

(20) High in the mountains of Austria are located numerous summer barns such as this small shelter. Featuring relatively rough construction techniques, the log barn is really the result of several lean-tos and sheds brought together to give shelter to the farmer, his summer feed, and younger additions to the herd.

(25) This barn at L'Ange-Gardien, Quebec, could easily have been mistaken for a home. Starting with a hip-on-gable roofline that was flared at the eaves, the unusual design continued with hipped dormers, ornate cupola, and generous window light for main and upper level. It has been torn down.

(26, 27) A floor plan typical of traditional Quebec design, this long connected barn once stood in the Baie St. Paul area of that province. Short, heavy poles were joined together and laid along the ridge-way to anchor the thatch cap. Thatched roofs have long since disappeared from Quebec farmyards.

(28) This unique combination of bellcast roofline for the upper portion and mansard sides presents a profile that was transplanted to Western Canada, primarily for urban dwellings. An open cupola completed this barn near L'Islet, Quebec.

(30) This barn at Oak Park Farm in Ontario was new during the province's wheat boom period, and extra money was available to have it gussied up for public appreciation, as well as practical farm use. Three earth ramps to separate areas of the upper level indicate distinctive storage areas for feed, implements, and seed.

(32) The end-drive barn is characteristic of central Halton County, Ontario's settlement by Scottish lowlanders in the early 1800s. Built in 1882 by William Elliott, the 120-foot-by-56-foot barn now is located at the Ontario Agricultural Museum.

(34) The Covenhaven barn at St. Andrews, New Brunswick, built for Sir William Van Horne, is impressive in both scale and self-containment. Twin silos flank the main four-level barn, with a wind-powered grinding mill anchoring the large wing. As with many Maritime barns, shingles were a principal exterior covering.

(35) Photographed earlier this century, this long stone stable at Middle Cove, Newfoundland, is reminiscent of similar structures built in older and rockier regions of the British Isles in the 1800s or earlier.

(37) Logs of large dimension were hard to come by in many regions of the West. In this example near Poplarfield, Manitoba, the main framing is provided by 10-inch-by-18-inch squared logs grooved on the sides to receive the smaller-dimension squared logs that were dropped into place one on top of the other until the wall was complete. The Rostkowski family built the barn in 1920 and incorporated several features that suggest above-average talents. First, corner angle braces were fashioned into the fill logs to provide improved stability against wind shifts. Second, the hip-style cap roof on either end was extended to provide improved but weatherproof ventilation for hay storage.

(38) The Mennonites came to Saskatchewan in the late 1870s, and many settled in several small villages south of Swift Current. Many of their house-barns can still be seen in these villages, which take the old form of a long main road dissecting a tightly clustered community of families. This unusual example telescopes from house to storage area to animal area.

(39) One of the most agonizing settlement stories was that of the Icelandic people, who, after losing entire families along the trek to western lands found only marginal farmland awaiting them. Their first buildings reflected their new environment as much as their impoverished condition. Vertical logs pounded into the ground (or sitting on log sills) were used to build early barns that served the small land holdings at New Iceland. The majority of settlers instead took to fishing as a preferred way of life.

(40) The original thatched house, stable, and shed stand before the buildings of more modern frame design. The location of this farmyard is not known, although it clearly displays layered thatching methods, as well as the common technique of anchoring the roof cap of thatch with small poles tied together at right angles.

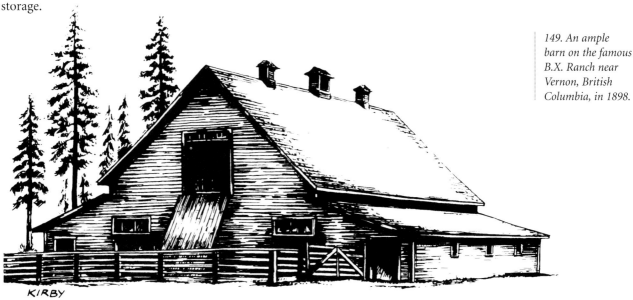

149. An ample barn on the famous B.X. Ranch near Vernon, British Columbia, in 1898.

KIRBY

(41) While early settlement shelters were often crude and temporary, the Ukrainian farmers exhibited great craftsmanship in their second generation of farm buildings. This picture was taken about 1906 near Foley, Manitoba. The relatively new stable offered an excellence of thatching technique to provide a weather-secure stable for livestock.

(42) Some of the large house-barns developed small lean-to sheds at the end of the barn, often fitting snugly to existing rooflines. These were often used for poultry. Jacob Teichroob built his first barn in 1892 at Chortiz, Manitoba. Considered one of the better-maintained examples of its type, it has been moved to the Mennonite Pioneer Village at Steinbach, Manitoba.

(43) Barns and sheds were designed as much for farm wagons as they were for the animals that pulled them. A popular design of European countries was the grain or seed storage facility where the wagon could be loaded or unloaded under cover. The same design was often applied to small stables where the animals were to be quartered and the wagon stored under cover. Finnish farmers who previously worked for bridge crews on the transcontinental railways constructed barns like this near Three Valley Gap, British Columbia.

(44) Albert and Ephraim Iver came to Broomhill, Manitoba, in 1924 from the big city of Chicago. They went back a few years later, disillusioned about the widely promoted but elusive fortunes to be made in Western Canada. The two brothers were unable to make their ten quarter-sections pay the mounting farm bills, and left behind a twin-silo barn that still gives pleasure to every traveller in that southwest corner of the province. The 128-foot-by-36-foot barn is used for its original purpose by the Gervin family.

(47) A long saltbox roofline highlights this bank barn located east of Neepawa, Manitoba, as well as the prairie rarity of extended forebay or overshoot. It was built by A.E. Gowenlock just before the turn of the century, and all materials came from the nearby Riding Mountain National Park area. The cantilevered overshoot provided sheltered loading and unloading for feed supplies, plus the luxury of being able to hitch animals under a south-facing shelter.

(48) Few barns exist today on the scale envisaged by Walter Howie in 1905. Measuring 100 feet in diameter, each of its twenty sides measures 12 feet at the base of the fieldstone foundation, which itself required 4,500 cubic feet of hand-faced stone. It is regarded as one of the largest round barns in North America, a fact that draws numerous barn hunters into the abandoned farmyard in southeastern Saskatchewan.

(50) Built about 1916, this has become known as "Ma Bell's Barn," according to published reports, after a woman whose husbands met mysterious ends. Vertical siding covers both the main and loft levels, as well as the cupola. The barn is located a few miles northwest of Empress, Alberta, near the Saskatchewan border.

(53) The eight-sided barn was built in 1902 for James Logan and his farming operation near Bethany, Manitoba. Measuring 224 feet in circumference, the building displays vertical siding and a large central ventilation system through the cupola.

(54) James Hill brought in a carpenter from his native Iowa to build his round barn near Macdonald, Manitoba. The 12-sided structure featured central feeding, hay lift, and stalls for twenty horses. Shortly after the barn was completed in 1910, Hill returned to Iowa.

(55) This circular barn was for many years symbolic of one of Western Canada's most ambitious farming ventures, and in more recent years has become a regional historic symbol. Built over one hundred years ago, it was a most visual focal point for the Qu'Appelle Valley Farming Co. Ltd. and its famous manager Billy Bell, who at various times controlled more than one hundred square miles of farm land for a farm investment group. The barn itself is 64 feet in diameter and contains, in addition to an office, sufficient space for thirty-one stalls, four-thousand-bushel storage bins, and a loft large enough for one hundred tons of hay. Did his circular creation inspire other bright ideas? It seems it did, because during his Winnipeg retirement years Major Bell worked on developing a type of round galvanized iron granary for western crops, complete with patented ventilation equipment. It is worth noting that Bell has gone in history as a discoverer—by accident—of the summerfallow technique of crop rotation. At the time of the 1885 Riel Rebellion most of the available farm horsepower had been pressed into military service, and, as a result, Bell failed to get his crop planted. The following summer was a real scorcher, yet Bell's acreage produced an average yield while his neighbours failed to harvest a kernel. The advantage of letting fields lay fallow every second or third year seemed obvious, and the practice has since become commonplace in the more arid prairie zones.

(57) Dairy farms encircled every major North American city at one time, a typical example being the Cummings herd and barns near Winnipeg. This photo was taken about 1916.

(58) Cornelius H. Bartel came to Drake, Saskatchewan, from Marion County in Kansas about 1906, and completed the 60-foot-diameter barn about twenty years later. Like many of the round barns encountered in western regions, the Bartel barn is about 60 feet high. In addition to an earth ramp, this barn features laminated rafters and beams.

(59) A young crop is beginning to emerge before this unique six-sided log barn located east of Arborfield, Saskatchewan. Estimated to be only about 65 years old, the structure is an excellent example of western axemanship. Each of the hand-hewn log walls measures about 20 feet in length and is 8 feet high. Built for Nile Hawley's livestock, the barn is divided equally down a north-south median, with horses stabled on one side and cattle on the other. The larger dormer windows gave easy access to field crews unloading hay wagons.

(60) Benjamin Roper left Yorkshire, England, with his father and mother about 1880 and settled with other family members in the Hartney, Manitoba, area the following year. He did not practice his trade of stone masonry until almost twenty-two years later when this distinctive barn was built on the original homestead. Two features set the barn apart from others: its hipped gable roofline, and the wooden ramps leading to second-storey loft storage. Most farmers who desired wagon access to upper levels built their structures into the side of a hill or built large earth ramps.

(61) Arthur Philips came to the Rocky Mountain House area of Alberta in 1912 after graduating from the Quebec agricultural college. Round barns were popular in parts of Quebec, and the five Philips boys helped their father build his design about 1924. Local pine provided almost all building needs, including shingles.

(62) A line elevation shows the main features of a typical Western Canadian bank barn earlier in this century. This example also includes a root cellar located under an earth ramp leading to the upper level, a design feature that did not find wide acceptance with farmers.

(65) Late evening sun and well-weathered barns go hand in hand, particularly when the light captures the solid profile of bank barns in the West. Robert and James McQuay built this barn about 1915, fifteen years after coming west from Ontario. They made their own lime kilns for masonry materials, as well as facing the fieldstone themselves.

(67) Used by owner Peter Jantz to shelter registered Percheron horses, this barn featured an arch-styled roof built with eleven plank trusses, which created unusually large feed storage areas in the loft.

(68) Not all bank barns were of gigantic proportions. This tidy little stable was built about 1900, and was designed for a more moderate scale of operation near Morden, Manitoba. Its fieldstone foundation remains in excellent condition and perhaps accounts for the straight conditions of the upper wood levels.

(69) The Knight barn at Raymond, Alberta, offered farmers an interesting variation in bank barns—if they, too, could find two small hills side by side. This barn allows the unusual advantage of loaded wagons entering one side of the upper storey and leaving empty at the opposite end.

(70) The barn built by William Baldwin in 1898 near Manitou, Manitoba, offers viewers two distinct features: a gable-on-hip roofline sometimes referred to as a Jerkenhead design and a bank barn that is a direct link to the owner's earlier farm experience in Ontario. A gentle slope provides sufficient elevation for a lower level that is dug back into the hill about 75 feet by 38 feet.

150. At the Trappist Monastery near St. Norbert, Manitoba, this barn boasted double entry above and below. The year was 1914.

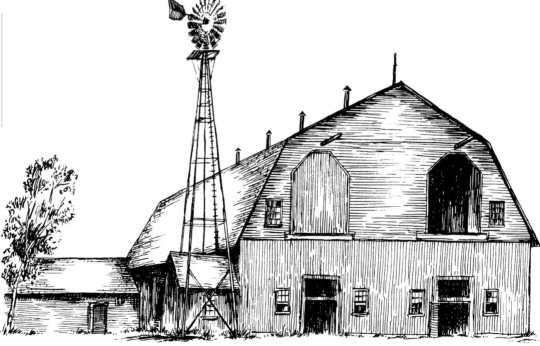

(71) The Shauman family took the long route to reach Lac du Bonnet, Manitoba, in 1912, leaving Latvia in 1894 and winding their way through Siberia to the United States by 1908. Andrew Shauman built this log barn a few years later, with hand-hewn logs from nearby forests. Son Fred later helped expand the original L-shaped log barn into a 40-foot-square barn with central cupola. It is one of the few surviving barns in the region that used materials from a nearby water-driven sawmill.

(72) A spectacular all-thatch barn was a rare discovery, but could have been found near several Mennonite settlements in southern Manitoba about 1875. The preferred rye straw, when properly applied, could provide farm shelter for between ten and twenty years, or even longer with proper maintenance. A wooden fence serves the unusual purpose of keeping farm animals from literally eating the barn.

(76) Log wall construction continued to be popular material for farmers well into the 1940s and 1950s. For veterans returning from the world wars it was often the most practical material for difficult financial situations. Hubert Izon, returning to the Dauphin area after being gassed and wounded in France, built this inexpensive 26-foot-by-40-foot barn with materials from nearby Riding Mountain National Park. Lime and horsehair were used as chinking material for the walls.

(77) Only in British Columbia will barn hunters find a farm building of such length and featuring continuous logs along the entire side of the barn. This example is found at 108-Mile along the Cariboo Highway, next to an almost complete heritage development of a restored roadhouse, post office, and several sheds and stables.

(80) One of the fastest methods of log barn construction was that of palisade or vertical construction. Logs were either driven into the ground or nailed to bottom rails, although early deterioration was the end result of either method. Typical of barns in parkland areas of the prairie provinces, this example was photographed about 1930 near Eagle Hill, Alberta.

(82) The Douglas Lake Cattle Company is one of the largest ranches in North America, covering about 500,000 acres of arid terrain in the British Columbia interior. There are many hundreds of abandoned barns and houses throughout the sprawling region, signalling the many smaller ranches that became part of larger operations such as the Douglas Lake spread over the past one hundred years. This barn has sunk a few inches over the years, bringing the second level floor almost to eye level. A contrast in building style is seen in the saddle notching used for barns and the more permanent, and difficult dovetailing of corners and squared wall treatment given to houses.

(85) Small poles provided a skeleton for supporting heavier clay covering materials in Manitoba's earliest settlement and difficult financial periods. This barn near Tilston had survived for many years prior to the Dirty Thirties, although the straw roof was in constant need of repair.

(87) Although the sky is beginning to peek through roof planking, and concrete blocks are starting to pull away in places, this tiny stable is in surprisingly good condition after more than eight decades of service to a farm in the Austin, Manitoba, area. One of many barns on the farm of Sir Walter Clifford, the 16-foot-by-32-foot building features the concrete blocks more often found in town residences. It was one of many cattle shelters used by one of Canada's foremost Aberdeen Angus breeders and organ-

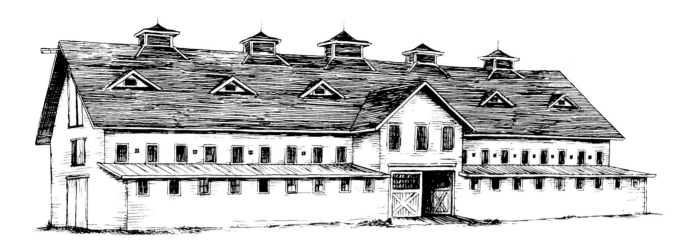

izers. The small wooden steps leading to a second storey have replaced the narrow earth ramp once used for horses quartered on the second level.

(88) Folks around Edgeley, Saskatchewan, have long called this farm building the "yellow church." They didn't think it looked like any barn design they were familiar with, although to young Scotsman Jack Howden, who had arrived from Scotland before the turn of the century, the design came from countryside memories of home. He made many trips to Weyburn over long, bumpy roads by horse and wagon to fetch the yellow brick for his horse barn and harness room.

(90) Fieldstone was often used in the Carlyle area of Saskatchewan. The stables of George Anderson were almost new at the time this photo was taken, featuring the gable-end stone walls rising right to the roof peak. This feature brought from the British Isles sometimes did not sit well on Western Canada soils. In fact, many gable-end walls were later rebuilt of framed lumber because the heavier stone tended to shift or tumble on prairie clay.

(92) Farmers made many types of bricks from local and unusual materials. Mennonite settlers, for example, made small bricks out of manure

and straw, also using them to heat their buildings until farms became more economically established. Mud, straw, and manure were also combined to make building bricks, although this barn at Glidden, Saskatchewan, was built without the benefits of the manure.

(95) They were still building large barns near Brandon in 1911, and in fact were pushing for materials and designs that could accommodate even larger-scale ambitions. This 110-foot-by-50-foot barn is shown by line elevation to emphasize the shift to truss systems for larger loft areas, and the use of cement for foundation walls. The Shields barn also provided an unusually large area for well-remembered local barn dances.

(97) No single photograph could more graphically illustrate the progression of barn building periods or materials than this Hugh McPherson barnyard near the Brandon Hills. Starting with temporary initial structures, which included sod roofs, farm buildings improved when financial conditions improved. The progression continued to a log-and-frame stable. Then, when wheat prices were right, modern materials such as concrete block and framing materials were used to build large structures.

(98) Temporary barns were constructed of many materials and forms. T. Hellis built this canvas-top version when he homesteaded near Gladstone, Manitoba.

(99, 101) The plan and the result: the Canadian Pacific Railway had millions of acres of farmland to sell and it used many incentives to move the acreage as quickly as possible. One method was ready-made farms, or plans for settlers to help construct farm buildings. The No.7 barn in their plan book was popular, particularly in Alberta where this example was photographed near Vulcan.

(100) The Beatty barn books usually tried to highlight some of the more progressive barn designs in Western Canada. The beautiful Percy Lasby barn outside Moose Jaw, Saskatchewan, was particularly enormous. Built in 1926 by W.L. Jones, the large U-shaped barn featured the latest designs in dairy farming and equipment—Beatty Bros. equipment from Fergus, Ontario, of course.

(103, 104) Two further examples of Canadian Pacific ready-made farms: newly completed barns and houses ready for occupancy in southern Alberta in 1913. Barn No.7 had a price tag of $1,050 at that time.

(105) There are few barns anywhere in the world to match the majesty of the University of Saskatchewan livestock barns, either in its 200-foot-by-140-foot, L-shaped dimensions or its excellent state of repair after more than 80 years of use. Originally used to stable dairy cattle and field horses, the barn is now used for dairy calves, maternity facilities for dairy cows, and housing animals used in metabolism studies. The barn has been designated as an historic site.

(110) The starkness of dying oak trees provided a symbolic frame for this example of a dying farm industry. In 1927, the Langtree Fur Farm near Stonewall, Manitoba, was exporting breeding foxes for $1,500 an animal and getting up to $400 a pelt for average-quality fox furs. A few years later prices started to decline, and by the time they hit $15 a pelt most fox farms and their unique barn towers were out of business.

(111) Lighthouse or fox tower? The question jumps to the mind of any traveller in the vicinity of Steinbach, Manitoba. Built in 1936, the tower was used to watch the mating habits of 100 female foxes. First, observers had to note the time of mating so that the male could be moved along to his next assignment. This also allowed the farm operator to estimate when pups would be born. The tower was again needed at the time pups were born, mainly to guard against creating unnecessary pen-area tensions, which sometimes caused females suddenly to kill their young.

(112) Dark clouds move into this picture of Doune Lodge, once a famous ranch for championship Clydesdale horses. Built at the turn of the century by local stone mason William Anderson, the 80-foot-by-100-foot barn housed the valuable breeding stock of Scotty Bryce, who had immigrated to the Arcola, Saskatchewan, area in 1882. The barn also housed workhorses for the three sections of farmland, half of which was in crop. Featuring large driveways leading to opposite sides of the barn's upper level, the loft also contained enormous feed bins and water tanks for animal guests below.

(116, 117) In 1923, sheep herds filled some of the facilities at Union Stockyard in Winnipeg, a fitting portrait of a facility barely ten years old. Within a few years, more than forty barns would stand at the stockyards, each measuring about 125 feet by 50 feet. The colour photo characterizes the condition of the stockyards in 1984.

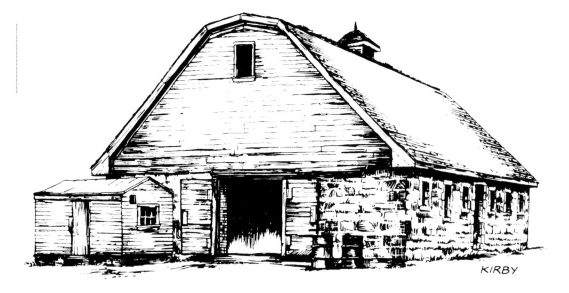

152. Prisoner-of-war camp barn built about 1919 near Birch River, Manitoba.

KIRBY

(118) Large timbers normally used for railway construction highlight the features of this barn located on what used to be a Canadian Pacific Railway farm at Strathmore, Alberta. The farm also had a barn, no longer standing, that in any other setting could easily be mistaken for a railway repair and maintenance shop.

(120) A long line of freight wagons stretches beyond the range of the camera in this 1867–68 photograph of Forest House, forty-three miles from Yale, British Columbia, on the Cariboo Highway. Ready to leave the depot is a six-horse passenger wagon, while four- and six-horse freight teams wait to resume their journey northward. Note the small wagons hooked in behind large freight wagons—much the same concept as the pup trailers of the modern-day trucking industry.

(121) This tiny barn near Blackie, Alberta, leads two lives. In real life it is an abandoned small frame barn, no different from many hundreds across Western Canada. In Hollywood, however, it is the barnyard where Superman (Clark Kent) grew up with his foster parents on Earth, before leaving for a lifetime of fighting crime in comics and movie theatres. For a brief time in the summer of 1977, the barn and house were renovated, the yard trimmed, and garden planted. Clark Kent's foster father died in the yard and Clark later dug beneath the barn's wooden floor to retrieve his links with planet Krypton. Then he and the film crew were gone.

(122) One of the famous B.X. passenger coaches is parked in the alleyway of the main barn at British Columbia's Cottonwood House. Next door, under the lean-to of another stable sit the freight wagons that plied the same Cariboo Highway during Gold Rush days. A few miles from famous Barkerville, the Cottonwood House is one of the better examples of roadhouses that offered shelter along the Cariboo trek, but was also a supply store for more permanent residents of the area who required reasonably priced staples.

(123) Another Doukhobor barn, this one is located at the heritage museum near Grand Forks, British Columbia. The smaller dimensions suggest a stable suited to a small land holding, with seed, vegetables, and feed kept in the upper loft and made accessible by the wide staircase and landing.

(124) One of the most distinctive barn forms in North America, the large Pennsylvania bank barn with its overhanging hay mow or overshoot, did not travel west intact with the late-

nineteenth-century settlers. The gigantic timbers required for such extensions were not readily available. A rare sight, therefore, is the reconstructed Egge barn at Fort Edmonton, Alberta. It is one of the few barns in the West with a small extended forebay, and perhaps results from the fact that Newton Egge was originally from Pennsylvania. He had the barn built about 1900, complete with an office to handle the business of providing shelter and feed for up to thirty teams of horses that came nightly to this well-known stopping house on the Athabasca Trail. One might stress that the Pennsylvania bank barn style was not duplicated exactly in the West, although many features of the Pennsylvania bank barn were adapted to prairie conditions.

(125) The Christian Union of Universal Brotherhood's long search for a peaceful existence in a new land came to an end near this barn. It was the last communal barn built by the Doukhobors, a large frame design set against the rugged beauty of the foothills near Cowley, Alberta. After the 1916 communal construction under the direction of Cecil Maloff, future Doukhobor barns came under individual ownership and use. The 60-foot-by-120-foot bank design features a wagon drive to the upper level, as well as an upper floor built entirely of hardwood. The barn was used to house the field horses of farmers who had originally left Russia near the turn of the century and attempted settlement in Saskatchewan and British Columbia prior to Cowley. Located a few yards from the barn is a log bathhouse where Doukhobor families bathed in traditional communal style.

(126) Built about 1905 at Veregin, Saskatchewan, a Doukhobor communal barn was located close to the town's mill where farmers had to draw their grain for sale or milling. While the materials speak of modern attitudes, the design of the barn shows difficulty in throwing off traditional design thoughts from the Old Country. A Doukhobor farmer would leave his grain at the mill one afternoon, bed himself and his team down for the night at the communal barn, and the next morning get his flour and feed from the mill and return home.

(127) Superintendent Samuel B. Steele brought seventy-five North West Mounted Policemen and their horses to the East Kootenay area of British Columbia in 1887, hoping to avert potential gold rush troubles, as well as problems associated with the building of a local railway. They built temporary shelters and stables for their mounts, some of which have been restored for public viewing. The NWMP settled the trouble without a shot being fired and a grateful town later named their growing community in honour of Superintendent Steele, who would leave with his men within one year of arriving.

153. One of Saskatchewan's largest barns, near Kamsack used for marshalling horses for war duty overseas.

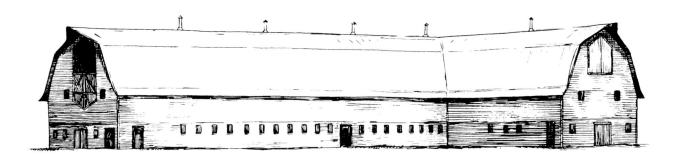

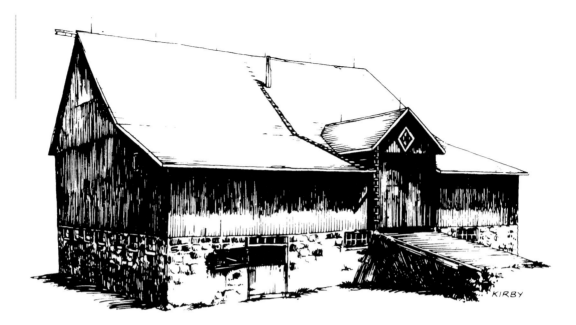

KIRBY

(129) William Neale came to Canada from England and after a brief settlement in Saskatchewan finally set roots down near Golden, British Columbia, in 1922. Nine years later, he and his sons built this 30-foot-by-32-foot cedar log barn for the farm's milk cows. Hauling the timber three logs at a time from Willowbank Mountain five miles away, the Neale family also hand-split its shingles for the roof. But one can't get completely away from outside or city dependence—even in bountiful British Columbia. In this case, ten small windows for the Neale barn were ordered from Eaton's catalogue.

(133) No paint manufacturer could possibly formulate the matching hues of a golden prairie or rust-topped barn in central Saskatchewan. Located near Melaval, this enormous example of earlier agricultural needs was built about 1908 by Louis Perry. But while the barn speaks of a larger scale of farming, the small house behind signals a more modest scale of value. The house was significant to early farming in the area as homesteader Perry also operated the only general store in the area for many years.

(135) Expert construction and well-chosen materials are highlights of this series of farm buildings in Manitoba's Interlake region. Long straight logs, squared and dovetailed, provide solid support for an extended loft gable, which is a common feature of other Ukrainian barns in the region. Built about 1925, the buildings have remained weathertight for their owner.

(144) The trademark of Fraser Valley dairy farms: twin silos puncturing a lazy mist of fall. The barns reflect a design and progression of building materials identical to that of their dairy brethren elsewhere in Western Canada.

(145) This is a crisp illustration of the Red River frame technique of barn building, including corner bracing, which was not always found on early barn types. It also shows liberal use of chinking materials to cover cracks left by warped logs. It was built about 1925 in the Rorketon area of Manitoba.

Image Credits

Except for those listed below, photographs in this book are those of the author. All line drawings are by Jim Kirby, Winnipeg, based on photographs from the provincial archives of Manitoba, Saskatchewan, Alberta, and British Columbia.

Chapter One: Introduction

2, 3, 4 – Institute of Agricultural History and Museum of English Rural Life, University of Reading

6 – National Museum of Ireland

7, 24 – Inbel, Brussels, Belgium

8 – Land esbildstelle, Westfalen

10, 21 – Norsk Folkemuseum, Oslo

11, 19 – Film-Und Lichtbildstelle, Wien, Austria

12 – National Museum of Finland

13, 14, 15, 16 – Ethnographical Museum, Budapest

17, 18, 20 – Wolfgang Milan, Wien, Austria

22, 23 – German Information Centre, New York

Chapter Two: Cultural Signposts

26, 27, 29, 31, 34, 36 – Public Archives Canada

28, 32 – Historic Resources, Province of Manitoba

33 – Ontario Agriculture Museum, Milton

35 – Public Archives Nova Scotia

36 – Glenbow Institute Archives, Calgary

38, 39, 40, 46 – Provincial Archives of Manitoba

41 – Ed Ledohowski

45 – Regina Public Library

Chapter Three: Shapes of Heritage

53, 63 – Provincial Archives of Manitoba

66, 68 – Historic Resources, Province of Manitoba

69 – Public Archives Canada

Chapter Four: Materials of Progress

74, 79, 85, 89 – Provincial Archives of Manitoba

76, 77, 78, 86, 90, 91, 92 – Saskatchewan Archives Board

81, 99, 98 – Public Archives Canada

83, 101, 102, 104, 105 – Glenbow Institute Archives, Calgary

84 – Sir Alexander Galt Museum, Lethbridge, Alberta

96 – Historic Resources, Province of Manitoba

Chapter Five: Mirrors of Diversity

97, 116, 125, 129 – Glenbow Institute Archives, Calgary

106, 115, 128 – Provincial Archives of Manitoba

107, 119 – Provincial Archives of Alberta

108, 120 – Public Archives Canada

111, 123, 126 – Provincial Archives of British Columbia

Chapter Six: Climate and the Land

130 – Saskatchewan Archives Board

133 – Saskatoon Public Library

134 – Provincial Archives of Manitoba

139 – Historic Resources, Province of Manitoba

145, 146 – Provincial Archives of British Columbia

Selected Bibliography

Apps, Jerry, and Allen Strong. *Barns of Wisconsin.* Madison, WI: Tamarack Press, 1977.

Arthur, Eric, and Dudley Witney. *The Barn, A Vanishing Landmark in North America.* Toronto, ON: M.F. Feheley Arts Co., 1972.

Beatty Bros. *B.T. Barn Books.* Fergus, ON.

Early Buildings of Manitoba. Winnipeg, MB: Peguis Publishers, 1973.

England, Robert. *The Colonization of Western Canada.* London, Eng.: P.S. King & Son, 1936.

Fitchen, John. *New World Dutch Barn.* Syracuse University Press, 1968.

Gaillard-Bans, Patricia. *Traditional European Rural Architecture.* UNESCO, 1980.

Gray, James H. *Boomtime.* Saskatoon, SK: Western Producer Prairie Books, 1974.

Halstad, Dr. Brian. *Barn Plans and Outbuildings.* New York, NY: Orange Judd Company, 1893.

Harvey, Nigel. *History of Farm Buildings in England and Wales.* Devon, Eng.: David & Charles, 1970.

Jones, Robert Leslie. *History of Agriculture in Ontario.* Toronto: University of Toronto Press, 1946.

Ledohowski, Edward M., and David K. Butterfield. *Architectural Heritage Series.* Manitoba: Historic Resources Branch. Province of Manitoba, 1983, 1984.

Lehr, John C., "The Log Buildings of Ukrainian Settlers in Western Canada." *Prairie Forum.* Vol. 5, No. 2 (1980-81).

Louden Machinery Company. *Louden Barn Plans.* 1917.

Lugar, R. *Country Gentlemen's Architecture.* 1807.

Mealing, F.M. *Doukhobor Life.* Castlegar, BC: Cotinneh Books, 1975.

MacKintosh, Wm. A. *Prairie Provinces, The Geographic Setting.* Toronto, ON: Macmillan of Canada, 1934.

McEwan, Grant. *Fifty Mighty Men.* Saskatoon, SK: Western Producer Books, 1958.

McEwan, Grant. *Illustrated History of Western Canada Agriculture.* Saskatoon, SK: Western Producer Prairie Books, 1980.

Mix-Foley, Mary. "The American Barn." *Architectural Forum.* (Aug./Sept. 1951).

Radford Architectural Co. *Radford's Practical Barn Plans,* 1909.

Rawson, Richard. *Old Barn Plans.* Clinton, NJ: Main Street Press, 1979.

Ross, Alexander. *Red River Settlement.* Edmonton, AB: Hurtig Publishers, 1972.

Rural Development and Planning—Commission of Conservation. Vols. 1–3, 1917.

Seguin, R.L. *Les Granges du Québec.* National Museum of Canada, 1963.

Simundsson, Elva. *Icelandic Settlers in America.* Winnipeg, MB: Queenston House Publishing, 1981.

Sloan, Eric. *An Age of Barns.* New York, NY: Ballantine Books, 1974.

Tyman, J.L. *By Section, Township and Range.* Brandon, MB: Assiniboine Historical Society, 1972.

Whitlock, Ralph. *Gentle Giants—The Past, Present and Future of the Heavy Horse.* 1976.

Wonders, William, and Mark Rasmussen. "Log Buildings of West Central Alberta." *Prairie Forum.* Vol. 5, No. 2 (1980-81).

Woodall, Ronald. *Magnificent Derelicts.* Vancouver, BC: Douglas & McIntyre, 1975.

Woodall, Ronald, and T.H. Watkins. *Taken by the Wind, Vanishing Architecture in the West.* Don Mills, ON: General Publishing, 1977.